ON PAPER

O'Keeffe

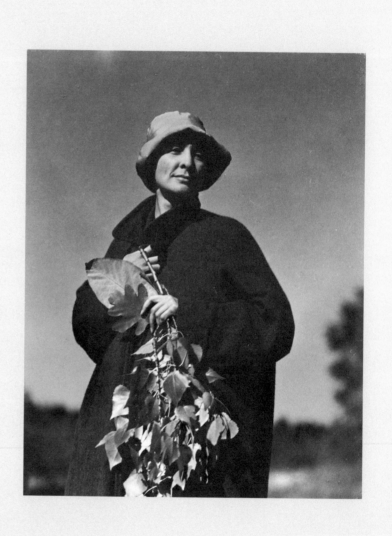

Ruth E. Fine and
Barbara Buhler Lynes
with
Elizabeth Glassman
and Judith C. Walsh

National Gallery of Art
Washington

Georgia O'Keeffe Museum
Santa Fe

Distributed by
Harry N. Abrams, Inc.,
Publishers

ON PAPER

O'Keeffe

The exhibition is made possible by
The Henry Luce Foundation,
The Georgia O'Keeffe Foundation,
and the National Advisory Council
of the Georgia O'Keeffe Museum

The exhibition is organized by the
National Gallery of Art, Washington,
and the Georgia O'Keeffe Museum,
Santa Fe

EXHIBITION DATES
National Gallery of Art, Washington
9 April–9 July 2000

Georgia O'Keeffe Museum, Santa Fe
29 July–29 October 2000

CURATORS
Ruth E. Fine and Barbara Buhler Lynes

Produced by the National Gallery of
Art with the Georgia O'Keeffe Museum
Senior Editor, Mary Yakush
Production Manager, Chris Vogel

Edited by Julie Warnement
Designed by Margaret Bauer

Typeset in Sabon and Myriad by the
National Gallery of Art, Washington

Printed in England by Balding +
Mansell on Mohawk Superfine

The clothbound edition is distributed
by Harry N. Abrams, Incorporated,
New York

LIBRARY OF CONGRESS
CATALOGUING-IN-PUBLICATION
DATA

Fine, Ruth, 1941–
O'Keeffe on paper / Ruth E. Fine and
Barbara Buhler Lynes with Elizabeth
Glassman and Judith C. Walsh
 p. cm.
Catalog of an exhibition held at the
National Gallery of Art, Washington,
D.C., Apr. 9–July 9, 2000 and the
Georgia O'Keeffe Museum, Santa Fe,
N.M., July 29–Oct. 29, 2000.
Includes bibliographical references.

ISBN 0-8109-6698-0
(cloth : alk. paper)
ISBN 0-89468-275-X
(pbk. : alk. paper)

1. O'Keeffe, Georgia, 1887–1986—
Exhibitions.
I. O'Keeffe, Georgia, 1887–1986.
II. Lynes, Barbara Buhler, 1942–
III. National Gallery of Art (U.S.)
IV. Georgia O'Keeffe Museum.
V. Title.

N6537.039 A4 2000
759.13—dc21 99-089039

NOTE TO THE READER
Titles and dates cited in this volume
reflect those used in Barbara Buhler
Lynes, *Georgia O'Keeffe: Catalogue
Raisonné* (London and New Haven,
1999).

Dimensions are given in centimeters,
followed in inches within parentheses,
with height preceding width.

ILLUSTRATIONS
cover: Georgia O'Keeffe, *Pink Shell
with Seaweed,* c. 1938, San Diego
Museum of Art, Gift of Mr. and Mrs.
Norton S. Walbridge (cat. 48)

frontispiece: Alfred Stieglitz, *Georgia
O'Keeffe: A Portrait,* 1924, gelatin
silver print, National Gallery of Art,
Washington, Alfred Stieglitz Collection

page 12: Ansel Adams, *Alfred Stieglitz
and Painting by Georgia O'Keeffe,
An American Place, New York City,*
1939, gelatin silver print, 1981,
National Gallery of Art, Washington,
Gift of Virginia B. Adams

page 38: Alfred Stieglitz, *Georgia
O'Keeffe: A Portrait—with Painting,*
probably 1922, gelatin silver print,
National Gallery of Art, Washington,
Alfred Stieglitz Collection

page 56: Alfred Stieglitz, *Georgia
O'Keeffe: A Portrait—with Watercolor
Box,* 1918, gelatin silver print, National
Gallery of Art, Washington, Alfred
Stieglitz Collection

page 80: Alfred Stieglitz, *Georgia
O'Keeffe: A Portrait,* probably 1921,
gelatin silver print, National Gallery
of Art, Washington, Alfred Stieglitz
Collection

page 138: John Loengard, *A Sunset
Walk over Red Hills,* late 1960s,
LIFE Magazine © Time Inc.

Foreword and Acknowledgments

The extraordinary career of Georgia O'Keeffe spanned much of the twentieth century. By the mid-1920s, O'Keeffe was celebrated as one of America's preeminent modernist painters. With remarkable clarity she integrated sensuous and intellectual concerns. Her fascination with the world of nature was balanced by her exploration of the principles of abstraction that were central to her artistic milieu.

O'Keeffe was prolific. The O'Keeffe catalogue raisonné (1999) by Barbara Buhler Lynes, a collaboration between the National Gallery of Art and The Georgia O'Keeffe Foundation, Abiquiu, documents approximately one thousand paintings and works of sculpture, and an equal number of works on paper. Research toward that publication provided fascinating insights into O'Keeffe's oeuvre and reinforced our plans to exhibit the works on paper in celebration of this jewel-like aspect of O'Keeffe's art. We hope that this selection of watercolors, pastels, and charcoals will inspire a greater appreciation of Georgia O'Keeffe's originality and of her important contributions to the history of American art.

We are most grateful to Juan Hamilton for his assistance with this exhibition. We thank him and other members of The Georgia O'Keeffe Foundation Board of Directors, in particular, Raymond R. Krueger, chairman, and June O'Keeffe Sebring, for their interest in *O'Keeffe on Paper* from the outset and for the generous contribution that has helped to make the exhibition possible. We are also indebted to The Henry Luce Foundation and to the National Advisory Council of the Georgia O'Keeffe Museum for their support.

Ruth E. Fine, curator of modern prints and drawings at the National Gallery of Art, and Barbara Buhler Lynes, curator of the Georgia O'Keeffe Museum and Emily Fisher Landau Director of the Georgia O'Keeffe Museum Research Center, have thoughtfully selected the exhibition and collaborated on the catalogue, which includes contributions from Elizabeth Glassman, president emerita of The Georgia O'Keeffe Foundation, and Judith C. Walsh, senior paper conservator at the National Gallery.

No exhibition is possible without the participation of many generous lenders. We are indebted to all of them for their willingness to part with their treasures for the public presentation of *O'Keeffe on Paper*.

Earl A. Powell III, Director
National Gallery of Art

George G. King, Director
Georgia O'Keeffe Museum

ACKNOWLEDGMENTS

An exhibition and its accompanying catalogue call for collaboration among institutions as well as with individuals. On behalf also of our fellow authors Elizabeth Glassman and Judith C. Walsh, we would like to thank those who have made our own efforts possible and rewarding.

First and foremost we thank the lenders to the exhibition, both private collectors and the directors and staffs of many institutions, especially The Georgia O'Keeffe Foundation. They have welcomed us into their homes and offices and shared our enthusiasm for Georgia O'Keeffe's art. Without their assistance and support the exhibition would not have been possible. We are also grateful to those who have granted us permission to study their works and to reproduce in this catalogue works by O'Keeffe and other artists.

Artist Juan Hamilton has graciously shared with us his extensive knowledge of O'Keeffe's art. We are grateful to The Georgia O'Keeffe Foundation's director, Agapita Judy Lopez, and staff Sarah L. Burt and Georgia Smith, who were especially helpful. We also thank Ellen Holtzman, program director for the arts at The Henry Luce Foundation, for her interest in our project and the following museum colleagues for facilitating loans: at the Amarillo Museum of Art, Patrick McCracken and Reba Jones; at the Addison Gallery of American Art, Andover, Adam Weinberg and Susan Faxon; at the Brooklyn Museum of Art, Arnold Lehman, Barbara Gallati, and Antoinette Owen; at the Fine Arts Museums of San Francisco, Harry S. Parker III and Karin Breuer; at the Hirshhorn Museum and Sculpture Garden, Smithsonian Institution, Washington, James T. Demetrion and Judith K. Zilczer; at The Hudson River Museum, Yonkers, Philip Verre and Lydia Fouto; at the Marion Koogler McNay Art Museum, San Antonio, William J. Chiego and Heather Lammers; at The Menil Collection, Houston, Susan Davidson and Paul Winkler; at the Museum of Fine Arts, Boston, Malcolm Rogers, Shelley R. Langdale, Roy Perkinson, and Theodore E. Stebbins, Jr.; at The Art Museum, Princeton University, Peter Bunnell, Norman Muller, and Barbara Ross; and at the San Diego Museum of Art, Steven L. Brezzo and Scott Atkinson.

At the National Portrait Gallery, Smithsonian Institution, Washington, we thank Wendy Wick Reaves, and at The Phillips Collection, Washington, Elizabeth Hutton Turner. To Doris Bry, Wanda M. Corn, Gayle Maxon-Edgerton, Lamar

Lynes, Deborah Ronnen, Alice C. Simkins, Paul Stenzel, Sharyn Udall, and Catherine Whitney we are also grateful.

At the National Gallery of Art we are indebted to Earl A. Powell III, director; Alan Shestack, deputy director; Carol Kelley, deputy to the director; Andrew Robison, Andrew W. Mellon Senior Curator of Prints and Drawings; the late Frances Smyth, editor-in-chief, and D. Dodge Thompson, chief of exhibitions, for their support. In addition we thank Naomi Remes and Jonathan Walz in the exhibitions office; Sally Freitag, Hunter Hollins, and Daniel Shay of the registrar's office; Ruth Anderson Coggeshall and Melissa L.B. McCracken in the development office; Deborah Ziska in the information office; Elizabeth Croog and Nancy Robinson Breuer in the office of the secretary-general counsel; Ross Merrill, Shelley Fletcher, Hugh Phibbs, Yoonjoo Strumfels, Constance McCabe, Rebecca Donnan, and Lehua Fisher in the conservation department for their patience and assistance; Ira Bartfield and Sara Sanders-Buell in photographic services; Sarah Greenough, curator, and Charles Brock in the department of photographs; and the ever helpful staff of modern prints and drawings, Ava Lambert, Carlotta Owens, and Charles Ritchie.

In the Gallery's editors office, we thank Mary Yakush and Chris Vogel for coordinating the work on the catalogue, Julie Warnement for her sensitive and careful editing, and Margaret Bauer for her beautifully elegant design. We are indebted to Mark Leithauser of the department of installation and design and his staff, including Gordon Anson, Barbara Keyes, Linda Heinrich, and John Olson, for the presentation of the exhibition in Washington; and to Genevra Higginson and her staff for orchestrating related special events.

At the Georgia O'Keeffe Museum, we are grateful to George G. King, director, and Theresa Harnisch Hays, associate director, for their strong support of the exhibition. Many staff members at the museum have also provided assistance and support: Judith Chiba Smith, registrar, Lisa Arcomano, research and collections associate, Ted Katsinas, communications, Elizabeth Martin, public relations, Jenifer Jovais and Susan Wider, development office and special events.

Ruth E. Fine and Barbara Buhler Lynes

Addison Gallery of American Art,
Phillips Academy, Andover

Amarillo Museum of Art

The Art Museum, Princeton University

Kirsten N. Bedford

Brooklyn Museum of Art

Ms. Doris Bry

Dr. and Mrs. John B. Chewning

Fine Arts Museums of San Francisco

Georgia O'Keeffe Museum, Santa Fe

Hirshhorn Museum and Sculpture Garden,
Smithsonian Institution, Washington

The Hudson River Museum, Yonkers

Mr. and Mrs. Leon E. Kachurin

Marion Koogler McNay Art Museum,
San Antonio

The Menil Collection, Houston

Museum of Fine Arts, Boston

National Gallery of Art, Washington

The Georgia O'Keeffe Foundation, Abiquiu

San Diego Museum of Art

Mr. and Mrs. Michael Scharf

Marion Stroud Swingle

Mr. and Mrs. William Taubman

Mr. and Mrs. Romano Vanderbes

Mr. and Mrs. Richard Waitzer

Private Collections

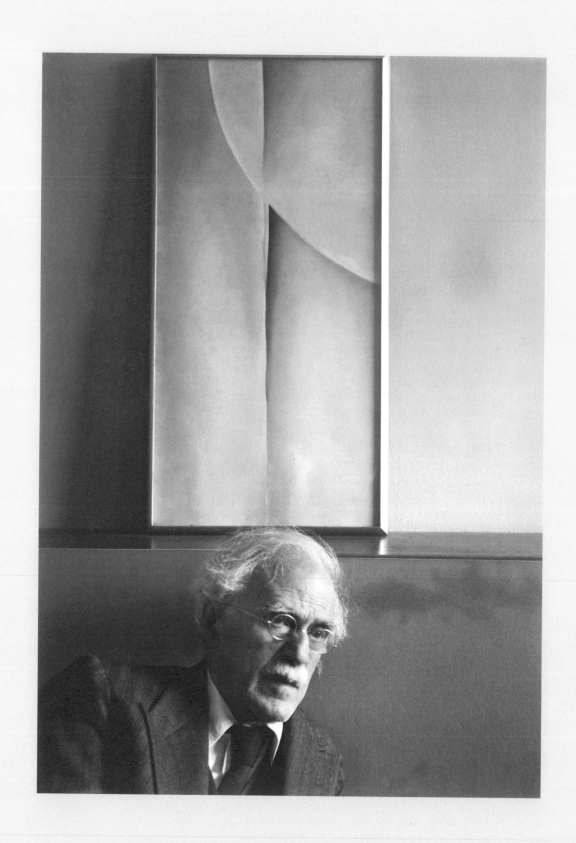

Thoughts without Words: O'Keeffe in Context

RUTH E. FINE

ELIZABETH GLASSMAN

INNER DISTANCE — THAT IS THE PLACE EXTRAORDINARY / WHERE SPEECH BEGINS —
THOUGHTS WITHOUT WORDS / PURE PEACE — WHEN THE HEART AND THE MIND / ARE
REMOVED FROM WORDS.[1] *Marsden Hartley*

Drawing has long played a central role as artists search for personal means of expression,[2] and the process was critically important not only for Georgia O'Keeffe (1887–1986), but also for other artists who, like O'Keeffe, were in the circle of Alfred Stieglitz (1864–1946) and received the ardent support of this renowned photographer, dedicated publisher, and art gallery impresario. Working on paper allowed these American modernists to synthesize ideas they had been taught and to formulate individual visual vocabularies. In their works on paper, they set down directions that would serve them throughout their artistic careers.

Writing in 1964, one year before O'Keeffe completed *From a River Trip* (cat. 55), the latest work in this exhibition, critic John Canaday pinpointed the nature of this endeavor:

In a drawing, an artist is most likely to summarize with maximum expertness and economy everything that he [or, as in O'Keeffe's case, *she*] has decided about what he believes in and everything that he has learned best in the control of its expression....to give us at full strength, but with minimum elaboration, the essence of whatever he has to say....But another kind of drawing is even more fascinating—the drawing where the artist is fighting things out with himself....And [the artist] is even more vulnerable, and can be even more triumphant, when his drawing is an arena for experiment and decision. [The artist] is most isolated yet most exposed in a drawing, since nothing else comes so purely from within or shows him to us more intimately.[3]

The triumph and intimacy of works on paper held great appeal for Stieglitz. It is noteworthy that of the more than 600 works of art (not including photographs by Stieglitz) donated from his estate to five American museums in 1949, approximately 470 were drawings, watercolors, and prints.[4] O'Keeffe, Stieglitz's widow and the executor of his estate, thoughtfully distributed his holdings by both European and American artists. Among the former were watercolors by Auguste Rodin, gouaches by Francis Picabia, and drawings by Henri Matisse (given to the Art Institute of Chicago); drawings by Pablo Picasso and lithographs by Henri de

Toulouse-Lautrec (placed at the Metropolitan Museum of Art, New York); and lithographs by Paul Cézanne and a watercolor by Paul Signac (presented to Fisk University, Nashville). Works by Marius de Zayas were also categorized as "foreign," even though the Mexican-born artist had emigrated to the United States in 1907 and remained for the balance of his career—over fifty years.

Artists listed as Americans represented in these gifts were Charles Demuth, Arthur Dove, Marsden Hartley, John Marin, O'Keeffe, and Abraham Walkowitz, this last an anomaly among the Americans because, like De Zayas, he was born in another country. All of these artists exhibited at one or more of Stieglitz's three important New York galleries: The Little Galleries of the Photo-Secession, located at 291 Fifth Avenue and commonly referred to as 291 (1905–1917); The Intimate Galleries (1925–1929); and An American Place (1929–1946).[5]

Stieglitz originally opened 291 for the purpose of exhibiting work by pictorialist photographers known as the Photo-Secession, champions in the fight to gain acceptance for photography as a fine art. The gallery soon became a gathering place for New York's avant-garde—avid readers of Stieglitz's journal *Camera Work* (1903–1917), which was filled with commentary about exhibitions, especially at 291; philosophical discourse; and exquisite photogravures by some seventy-five artists, including Gertrude Käsebier, Clarence H. White, Edward Steichen, and Stieglitz himself.

Before long, Stieglitz extended his reach beyond photography and beyond America's shores. As he expanded his purview, Stieglitz explained in the April 1907 *Camera Work* that "the Secessionist Idea is neither the servant nor the product of a medium." He intended to light the "lamp of honesty," and, in doing so, to support the "honesty of revolt against the autocracy of convention."[6] Among visual traditions visitors would find in his gallery were European modernism, in particular works on paper; African art; pre-Columbian pottery and sculpture; and art by children.[7] Steichen (1879–1973), a partner in the 291 venture, had encountered some of the most radical artists working in Paris during his frequent visits—the first in 1901–1902, others, intermittently, until 1914. He thereby was able to provide important artists' introductions to Stieglitz that were followed with shows at 291.

Except for O'Keeffe, the Americans represented in the Stieglitz bequest had traveled in Europe and were familiar with much of its modern art before Stieglitz

introduced it in New York several years in advance of the 1913 International Exhibition of Modern Art, best known as the Armory Show. Marin, for example, whose work Steichen brought to Stieglitz's attention, was based in Paris in 1909 when he first showed at 291 (his European travels lasted from 1905–1910). Demuth traveled in Europe as early as 1904, returning for five months in 1907–1908, and again from 1912–1914. Walkowitz, who had emigrated to the United States in 1889, moved back and forth between Europe and New York from 1907–1914. Dove left the United States for a year in Europe in 1908. De Zayas was abroad periodically from 1910–1914, and during these years, he, like Steichen, contributed to the content of exhibitions at Stieglitz's gallery. Hartley had seen many of these exhibitions prior to his first trip to Paris (1912) and Germany, where he associated with the *Blaue Reiter* group. He continued to travel back and forth across the Atlantic until the mid-1930s, and was an inveterate traveler within North America and Mexico as well. Even after returning to America, these artists could stay abreast of the latest artistic developments in Europe by visiting Stieglitz's exhibitions.[8]

In January 1908, Stieglitz presented fifty-eight watercolors by Rodin at 291 (fig. 1). Chiefly renditions of the nude in line and wash, the watercolors had been selected by Rodin and Steichen, who had been photographing both the sculptor and his famous bronze Balzac since 1901 (fig. 2).[9] Rodin's watercolors of nudes caused quite a stir in the New York art community, and, as reported in *Camera Work*, "during the three weeks [the watercolors] were shown, connoisseurs, art lovers of every type, and students from far and near flocked to the garret of 291. It was

1.

Auguste Rodin, *Sunset*, c. 1900–1905, watercolor and graphite on paper, The Art Institute of Chicago, The Alfred Stieglitz Collection

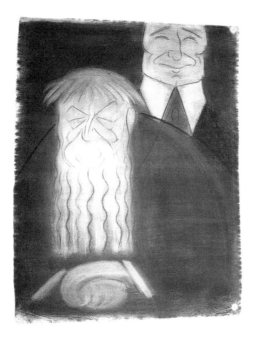

2.

Marius de Zayas,

Edward Steichen and

Auguste Rodin,

c. 1910, charcoal on

paper, Katharine

Graham

an usual assemblage—even for that place—that gathered to pay homage to one
of the greatest artists of all time." [10] One of those students was O'Keeffe, who
joined her classmates from the Art Students League to view the astonishing show.
This marked her first encounter not only with the fluid lines and transparent water-
color washes used by Rodin, but also with her future husband. Both made a lasting
impression. Ten years later, recovering in Texas from a bout with the flu, O'Keeffe
returned to the lessons of Rodin, making her own series of lush nudes in watercolor
(cats. 15, 16). [11]

Stieglitz's emphasis on displaying "foreign" works on paper continued over
the next several years. The Rodin exhibition was followed by a show of Matisse's
prints and drawings (and one painting). In 1911 visitors to 291 could view a
groundbreaking exhibition of twenty watercolors by Cézanne, mainly landscapes,
in which, characteristically, the role played by the white paper was as important to
the compositions as the pigment the artist applied to the sheet. Just as Picasso and
Braque had been inspired by Cézanne's art, so too were many American artists.
In particular, Marin and Demuth used the support sheet as a visually active element
in their works in watercolor, a medium that became primary as they searched
throughout their careers for expressive forms that mirrored the modern age.

Continuing his mission to introduce the newest artistic currents from Europe, Stieglitz followed the Cézanne show with more than eighty drawings and water-colors by Picasso. Four years later, in 1915, he mounted an exhibition that included not only drawings but also cubist collages by Picasso and by Braque. These works, assembled with the help of De Zayas in Paris, encompassed some of the most radical changes that the visual arts in general, and drawing in particular, had experienced in centuries.[12]

THE SPIRIT OF THE THING

As a practicing artist Stieglitz explored the medium of photography. Increasingly he has come to be admired for the sophistication of his printing techniques—the use of a variety of papers and chemicals to produce unique impressions that yielded individual interpretations of an image.[13] It is not surprising, therefore, that Stieglitz's orientation to other artistic media was rooted in his sensitivity to the distinctive possibilities of drawings and other works on paper.[14] Artists make drawings for a variety of reasons: to capture ideas in momentary sketches; to plan for works in other media; to assemble a storehouse of forms and techniques for future use; and to create independent works of art.[15] Some drawings, of course, fit into more than one category. The artists in the Stieglitz circle engaged in all of these practices, but of greatest concern here are the independent works that Stieglitz would have considered "equal [in] potential value" with paintings and sculpture, eschewing as he did the differentiation "between so-called 'major' and 'minor' media," because "it is the spirit of the thing that is important."[16]

For drawings, several elements contribute to the character of an image and play a crucial role in the appearance and expressive meaning of a work: the surface texture, weight, and color of the paper support; the choice of medium—watercolor, gouache, pastel, charcoal, graphite, ink, or some combination; the tools used to apply the media when appropriate; and the nature of that application. The quick sketch generally conveys an immediacy and freshness by capturing the essence of a subject without embracing a need for detail. By contrast, highly finished pieces—whether done swiftly and thinly, or whether reworked over time to build a dense layered sur-face—can provide greater complexity and a more extensive examination of a sub-ject. All of this would have been of interest to so experimental an artist as Stieglitz.

There is a fascinating tension between the strength and fragility of paper that seems to encourage or at least permit artists a special freedom. A readily available surface of seemingly infinite variety, paper is also easily transportable and thus may be carried far from the studio. Paper may be purchased in books of several sheets whose very form seems to suggest that if one sheet doesn't work out, another is immediately available for a new start; and paper is easily destroyed in the face of failure. At the same time, paper can be very, very tough, and may be reworked to an extraordinary extent. Moreover, drawings may be stored, even in great numbers, without the demand for space made by stretched canvases or sculpture. Thus working on paper, because it may seem a less "finished" activity than working in other media, encourages experimentation, new thoughts, and greater artistic risks, which differ both in kind and in degree.

Apart from Stieglitz's admiration for drawings and prints, there were practical reasons for such work to play a critical role in the discourse at 291. Less costly and easier to pack and ship, drawings also better suited the intimate scale of his gallery. In a 1914 letter to Stieglitz, Hartley expressed concern that paintings by Wassily Kandinsky, Franz Marc, and Paul Klee might be too large for 291; and in his autobiography Hartley described 291 as "probably the largest small room of its kind in the world."[17]

A logical outgrowth for artists who viewed the wealth of works on paper that Stieglitz brought to them was an excitement to try such techniques themselves. Indeed, Demuth, De Zayas, Dove, Hartley, Marin, O'Keeffe, and Walkowitz all turned to paper to explore some of their most central concepts. In this, they followed many of their artistic forebears: drawings, watercolors, and pastels had played an equally important role for the previous generation of American artists, both those working at home and abroad. For example, they had established a number of societies, including the Society of American Painters in Pastel (1880s) and the American Society of Painters in Water Color (1866), renamed the American Watercolor Society (1877).[18] In 1915, this society's *Forty-Eighth Annual Exhibition* gave O'Keeffe's work its first public display in New York. Later that year she was included in the *Twenty-Sixth Annual Exhibition* of the New York Water Color Club and in a show at the Philadelphia Water Color Club.[19] Essentially conservative, such societies nevertheless generated interest in drawing for artists, critics, and the public alike.

3.

James McNeill
Whistler, *Study in
Black and Gold
(Madge O'Donoghue)*,
c. 1883/1884, water-
color on paper,
National Gallery of
Art, Washington,
Gift of Mr. and Mrs.
Paul Mellon, in honor
of the 50th anniver-
sary of the National
Gallery of Art

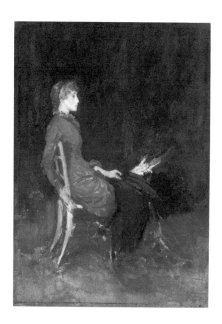

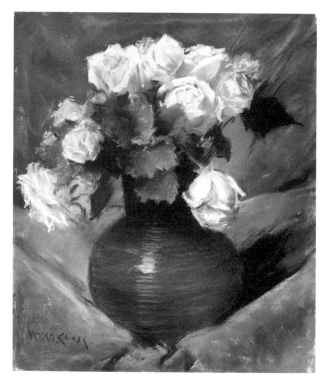

4.

William Merritt
Chase, *Roses,* c. 1888,
pastel on paper,
The Margaret and
Raymond Horowitz
Collection

And this appreciation grew: an exhibition of John Singer Sargent's watercolors held in 1909 at New York's Knoedler Gallery led to the purchase of eighty-three sheets by the Brooklyn Museum of Art. Writing twenty years after this momentous sale, critic Helen Appleton Read conjectured that "the widespread publicity attached to this event had considerable influence in stimulating an interest in water color painting."[20] Moreover, Margaret F. MacDonald's catalogue raisonné, *James McNeill Whistler: Drawings, Pastels, and Watercolours*, reveals this expatriate artist's extraordinary commitment to drawing, listing more than 1,700 works, from spare sketches to highly finished sheets such as *Study in Black and Gold (Madge O'Donoghue)* (fig. 3). Thomas Eakins, Winslow Homer, and Maurice Prendergast found vivid means of expression through watercolor; Mary Cassatt, William Merritt Chase, and Everett Shinn made extraordinary, highly finished pastel paintings, as they were called at the time. In fact, Chase, a cofounder of the Society of American Painters in Pastel, played a key role in the extensive use of pastel by late nineteenth-century American artists. Chase taught at the Art Students League, where O'Keeffe was one of his students from 1907–1908. Her lifelong interest in the medium of pastel as well as her choice of flower subjects may have been rooted in her admiration for such accomplished works as Chase's lush *Roses* (fig. 4), in which individual petals are carefully suggested. This work may, perhaps, be a forerunner of O'Keeffe's close-up views of flower subjects (cats. 28, 49, 50). Indeed, Chase had told his students: "there is nothing more difficult than flowers."[21]

Drawing was also crucial to American artists who, though contemporaries of the Stieglitz group, were exploring very different ideas, in particular social realism and realism. George Bellows, Edward Hopper, Reginald Marsh, John Sloan, and others all created significant bodies of work on paper, in a variety of media, ranging from brief sketches to meticulously realized sheets.

THE MOST BY MEANS OF THE LEAST

The complexity and density of the intellectual milieu in which the Stieglitz circle was immersed is reflected in Georgia O'Keeffe's library at Abiquiu, which includes, among her other books, numerous volumes that originally belonged to her husband. Early editions of works by Sherwood Anderson, Hart Crane, Havelock Ellis, Sigmund Freud, James Joyce, D.H. Lawrence, Lewis Mumford, Gertrude Stein,

and Carl van Vechten, among others, signal O'Keeffe's and Stieglitz's familiarity with the day's most advanced issues not only in literature and philosophy, but also in human sexuality, censorship, radical politics, and what Mumford called, "The Metropolitan Mileau."[22] At 291 these topics would have been the basis for extended conversations presided over by Stieglitz.

Artists, critics, historians, and theoreticians who were important observers of artistic issues for the group (and whose works are represented in O'Keeffe's library) included Clive Bell, Charles H. Caffin, Arthur Jerome Eddy, Waldo Frank, Henry McBride, Picabia, Paul Rosenfeld, Willard Huntington Wright, and, particularly, Arthur Wesley Dow and Kandinsky. Dow, chairman of the fine arts department at Teachers College, Columbia University (1904–1922), numbered O'Keeffe among his students in 1914 and 1915. His seminal book *Composition: A Series of Exercises in Art Structure for the Use of Students and Teachers* (1899) swiftly became a classic; it was certainly an enormously influential text during the early decades of this century. For Dow, the three crucial elements of drawing were line, color, and *notan*— "a Japanese word meaning 'dark, light' [that] refers to the quantity of light reflected, or the massing of tones of different values."[23] Dow's "principles of composition" or "ways of creating harmony" further include opposition, transition, subordination, repetition, and symmetry.

Dow's use of the term *notan* suggests the importance of Oriental traditions— both Chinese and Japanese—in the United States at that time. Critical to introducing these concerns were Cassatt and Whistler, who embraced ideas from the East while working in Europe. Embedded in their art, this aesthetic was transferred to America by their important collectors, including Charles Lang Freer and H.O. and Louisine Havemeyer. Important too were the writings of Ernest Francisco Fenellosa, an American who taught philosophy in Japan before serving as the first curator of Japanese art at the Museum of Fine Arts, Boston (1890–1896). It was under his instruction that Dow, as an assistant curator, absorbed the lessons of Asian art. Fenellosa's weighty, two-volume text *Epochs of Chinese and Japanese Art: An Outline History of East Asiatic Design* (1912) emphasizes that drawing has played a critical role, more so in the Eastern tradition than in the West, in what are considered major works of art. In paintings of the Southern Sung Dynasty (1127–1279), for example, artists drew with brush and ink on silk, achieving, as noted

by Philip Rawson, "the most by means of the least," a tenet that served members of the Stieglitz circle well.[24]

In May of 1909 Stieglitz presented an exhibition at 291 of Japanese prints from a New York private collection. That same year in Munich, Kandinsky's thinking was profoundly affected by the first major comprehensive exhibition of Japanese art held in Europe.[25] Like Dow, Kandinsky initially influenced artists in Stieglitz's circle through his writings. His *Concerning the Spiritual in Art*, issued in Munich in December 1911, was immediately translated into English by Stieglitz, who published an excerpt in *Camera Work* the following July.[26] When Hartley met Kandinsky in Munich in 1913, the German artist's impact on the American's work—as Gertrude Stein reported to Stieglitz later that year—was both immediate and powerful:

In his painting he has done what in Kandinsky is only a direction. Hartley has really done it. He has used color to express a picture and he has done it so completely that while there is nothing mystic or strange about his production, it is genuinely transcendent. There is not motion but there is an absence of the stillness that even in the big men often leads to non-existence.[27]

Kandinsky's thought strongly reinforced the bent in the Stieglitz circle toward visual abstraction, linking it with music, the most abstract of all the arts. In *Concerning the Spiritual in Art*, Kandinsky suggested that at no time in the past have "the arts approached each other more nearly than they do today, in this later phase of spiritual development. In each manifestation is the seed of a striving toward the abstract, the non material. Consciously or unconsciously they are obeying Socrates' command—Know thyself."[28]

The importance of art as a manifestation of self-knowledge is one that surfaces repeatedly in writings by and about the Stieglitz circle. In William Innes Homer's apt description, the 291 aesthetic—which evolved from exhibitions and discussions at the gallery and from articles published in *Camera Work*—incorporated two "cardinal principles: the work of art had to be a frank expression of the feelings of the individual who produced it, without regard for conventional rules or the styles of any other artists; and the creator of the work was expected to add something new to what had gone before."[29] Nowhere more than in drawings and other works on paper are these principles made visible.

Of the artists whose drawings are mentioned in this essay, De Zayas was the first to exhibit in a solo show at 291, in January 1909.[30] That spring, Marin's watercolors were included in a two-person show with paintings by Alfred Maurer. Hartley's first exhibition soon followed. In the summer, Stieglitz traveled to Europe, where Steichen introduced him to Marin; his first one-man show (all works on paper: watercolors, pastels, and etchings) at 291 took place early in 1910. Prior to that, in the autumn of 1909, Dove had returned to New York from more than a year of drawing and painting in Europe, and brought his work to Stieglitz. Immediately impressed, Stieglitz included one of Dove's pieces in the March 1910 exhibition *Younger American Painters,* which also included work by Hartley, Marin, Steichen, Max Weber, and Arthur B. Carles. Each of the latter two had one show only at 291, in 1911 and 1912 respectively. Dove's first solo exhibition also took place in 1912, highlighting a series of pastels entitled The Ten Commandments, including *Nature Symbolized No. 2* (fig. 5). That year closed with the first exhibition of work—both drawings and paintings—by Walkowitz. Four years later, in May of 1916, O'Keeffe's drawings were first seen at the gallery (cats. 1, 2, 4).

24

5.

Arthur Dove, *Nature Symbolized No. 2,* c. 1911, pastel on paper, The Art Institute of Chicago, Gift of Georgia O'Keeffe to the Alfred Stieglitz Collection

MARIUS DE ZAYAS

After emigrating to the United States in 1907 and earning Stieglitz's respect, De Zayas (1880–1961) organized several exhibitions at 291 and contributed to *Camera Work*. In addition, he wrote lengthy critical texts, including *A Study of the Modern Evolution of Plastic Expression* (1913), which he coauthored with Paul Haviland, and *African Negro Art: Its Influence on Modern Art* (1916). De Zayas eventually opened two galleries of his own, both dedicated to the avant-garde.[31]

For his expressive caricatures, De Zayas often preferred the large sheets of paper and rich grays and blacks that would later engage O'Keeffe in many of her early "Specials" (cats. 1, 2). Exemplary is *Edward Steichen and Auguste Rodin*, c. 1910 (fig. 2). The large-scale figures are realized by broad areas of darkness enveloping the two heads, economically defined by nervous lines and subtly placed tonalities. Highlights are achieved in areas of white paper, revealed by removing charcoal—a method similar to techniques O'Keeffe would use. Steichen was depicted as young and forthright in his high, starched collar, chin jutting forward. Rodin, realized in softer undulating lines, enjoys the privilege of his age and position as he leans on his cane. Using not only charcoal, as here, but also pen and ink, conté and lithographic crayon, and watercolor, often in combination, De Zayas portrayed the cultural elite of the period with acerbic wit and penetrating insight. As Wendy Wick Reaves has noted "in describing De Zayas's ability to reveal inner traits many commentators spoke of reaching the soul of his subject."[32]

JOHN MARIN

The soul of Marin's vast oeuvre is rooted in the land. Of some three thousand paintings that Marin (1870–1953) created over his long career, more than three-quarters are watercolors, often with lines in graphite, charcoal, colored pencil, or crayon.[33] A few late sketchbooks are worked in watercolor as well, although the others mainly employ linear media. Marin's work in pastel—executed during his early years in Europe, especially in Venice—pays homage to Whistler's economical style. Views of New York and Maine came to dominate Marin's oeuvre, and he made a splendid group of watercolors in New Mexico during the summer and autumn of 1929 and 1930, coinciding with the first two years that O'Keeffe spent extensive time in that region.

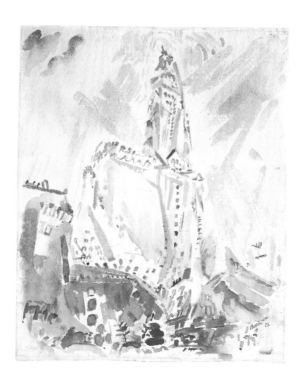

6.

John Marin, *Wool-
worth Building No. 31*,
1912, watercolor
on paper, National
Gallery of Art,
Washington, Gift of
Eugene and Agnes
E. Meyer

When the Woolworth Building opened in 1913, it was the tallest in the world. As such, it joined the Brooklyn Bridge as an important symbol of the modern city, a subject that yielded inspiration for Marin and others, including O'Keeffe, who executed several charcoal and pastel drawings of New York subjects (cats. 32, 40–42, 53). During the construction of the Woolworth Building, Marin captured its essence in several fully realized renditions in etching and watercolor, as well as in numerous sketches. *Woolworth Building No. 31* (fig. 6), with the exterior structure completed and the scaffolding removed, was worked freely and quickly; areas of white paper suggest Marin's admiration for Cézanne's openly worked watercolor landscapes. The younger artist's vigorous technique, which combines the use of dry brushstrokes with confined areas of fluid color, demonstrates a very different use of the medium than may be seen in O'Keeffe's watercolors from the teens, for example, the Blue Hill series (cats. 9–11), with their expansive pools of brilliant hue.[34]

The Woolworth Building drawings were exhibited at 291 in 1913, the year of the Armory Show. Marin explained the series in the catalogue that accompanied his exhibition:

I see great forces at work; great movements; the large buildings and the small buildings; the warring of the great and the small; influences of one mass on another greater or smaller mass. Feelings are aroused which give me the desire to express the reaction of these "pull forces," those influences which play with one another; great masses pulling smaller masses, each subject in some degree to the other's powers. While these powers are at work pushing, pulling, sideways, downwards, upwards, I can hear the sound of their strife and there is great music being played.[35]

Woolworth Building No. 31 and other watercolors in the series were acquired by Eugene and Agnes Ernst Meyer, important patrons of artists in the Stieglitz circle. Other patrons were Duncan and Marjorie Phillips, whose Phillips Memorial Art Gallery opened in 1921 as the first public institution in America devoted to modern art.[36]

MARSDEN HARTLEY

Hartley (1877–1943) produced fewer finished works on paper than did Marin and others who had been encouraged by Stieglitz, although sheets in a variety of media date from throughout Hartley's life. Especially beautiful are a number of relatively large charcoals and pastels in which he explored themes he later took up in oil. Among these is *Landscape No. 8*, 1919 (fig. 7). Hartley also left numerous

7.

Marsden Hartley, *Landscape No. 8,* 1919, pastel on paper, Collection Frederick R. Weisman Art Museum at the University of Minnesota, Minneapolis, Bequest of Hudson Walker from the Ione and Hudson Walker Collection

pencil studies, and drawings in pen and ink, which mainly depict trees and figures, singly and in groups; these works were also often associated with paintings. [37] Except for important symbolic works that embraced abstraction in the early teens, Hartley essentially remained clearly tied to nature throughout his career. In 1928 he cogently described that he had moved away from Kandinsky's ideas, which had inspired his earlier abstract period, and explained the necessity for starting in (and staying with) the visible world:

I have made the complete return to nature and nature is, as we all know, primarily an intellectual idea. I am satisfied that painting also is like nature, an intellectual idea, and that the laws of nature as presented to the mind through the eye—and the eye is the painter's first and last vehicle—are the means of transport to the real mode of thought; the only legitimate source of aesthetic experience for the intelligent painter. [38]

ARTHUR DOVE

Unlike Hartley, but like O'Keeffe, Dove (1880–1946) moved back and forth between representation and abstraction throughout his career. In their youth, both O'Keeffe and Dove worked on paper as illustrators, using highly graphic and stylized techniques. When Dove returned from Paris in 1909, in an effort to integrate the lessons from Europe into his personal vocabulary, he again experimented with new forms first on paper. He then put aside all efforts to adopt current styles and approached the sheet with great originality—a tack O'Keeffe herself would take four years later, in 1915. [39] By 1911 Dove was engaged in the forceful series The Ten Commandments (fig. 5), which signaled a radical shift in his art—a decisive move away from representation to a highly abstract, symbolic, and individual style. Exhibited in 1912 at 291, these works are among the earliest abstractions created by an American artist. [40]

O'Keeffe first became familiar with Dove's art through a reproduction of his 1911/1912 pastel *Based on Leaf Forms and Shapes* in Arthur Jerome Eddy's text *Cubists and Post-Impressionism* (first published, 1914). [41] Dove was the only American artist whose work was reproduced in this influential study; he was also represented by a lengthy statement concerning his approach to his work:

28

After having come to the conclusion that there were a few principles existent in all good art from the earliest examples we have, through the Masters to the present, I set about it to analyze these principles as they are found in works of art and in nature.

One of these principles which seemed most evident was the choice of the simple motif. This same law held in nature, a few forms and a few colors sufficed for the creation of an object.

Consequently....I gave up trying to express an idea by stating innumerable little facts, the statement of facts having no more to do with the art of painting than statistics with literature.

The first step was to choose from nature a motif in color, and with that motif to paint from nature, the form still being objective.

The second step was to apply this same principle to form, the actual dependence upon the object (literal to representation) disappearing, and the means of expression becoming purely subjective.[42]

Dove's penetrating statement illustrates a central difference between the kind of abstraction practiced by American artists of this period (based in nature) and that prominent in the work of their European counterparts (based in theory). Engaged with balancing a propensity toward the concrete with the most current European theories, which often emphasized abstract principles, Americans looked to the shapes and forms, the "thingness" of the world around them, to reveal their inner states.

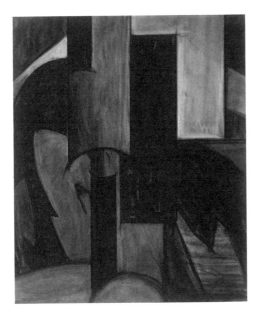

8.
Arthur Dove, *Abstraction*
Untitled, Nature Symbolized,
1917–1920, charcoal on
paper, Edward J. Lenkin

No matter how abstract their work may appear, it was emotionally rooted in the visible world.[43] For example, the lyrical *Nature Symbolized No. 2* (fig. 5) suggests the extent to which Dove absorbed the lessons of Kandinsky. Dove's pastel, however, is a hymn to nature grounded in natural forms and shapes, his tie to the object expanding in the subjective emotion of music and memory.

From 1911–1920, Dove also produced a group of charcoals that, like the pastels, explored states of nature and movement; among them was his *Abstraction Untitled, Nature Symbolized*, 1917–1920 (fig. 8). The force of conception explodes from the paper's boundaries, just as it does in many of O'Keeffe's early charcoals, such as *Crazy Day* (cat. 30). And Dove's work, like O'Keeffe's, received a critical response couched in sexual terms. Writing in *The Dial* in 1921, Paul Rosenfeld made abundantly clear his perception that Dove and O'Keeffe were complementary poles of male and female sensibility: "The organs that differentiate the sex speak." Dove was "a virile and profound talent" from whom "a male vitality is being released." O'Keeffe, however, was "spiritualizing her sex," for when women "feel strongly," it is "through the womb."[44]

In the 1920s, after Dove's powerful statements in pastel and charcoal, he turned to painting and collages, using not the drawn symbol of the object, but fragments of actual objects; the following decade, aboard his boat *Mona*, he again turned to paper, producing small, highly personal watercolors and gouaches.[45]

ABRAHAM WALKOWITZ

Walkowitz' years of closest association with Stieglitz, and with the imaginative development of an American avant-garde as it is generally understood, primarily date to the teens, ending with the close of 291 in 1917. On paper Walkowitz (1880–1965) worked in wash, pastel, graphite, charcoal, ink, and combinations of media, as in, for example, *Untitled (Abstraction)*, 1918 (fig. 9). His abstractions, whether geometric or biomorphic, were influenced by Kandinsky. Kent Smith categorized them as "Geometric Abstractions," "Dance Swirls," and "Vibrating Figures."[46] However, many of Walkowitz' preeminent modernist works depict New York; and his fractured forms, like Marin's, embrace the city's cubist, futurist activity. Walkowitz more than Marin suggested the density of the city as well as its movement, with layers of forms closely packed as they move across a surface.

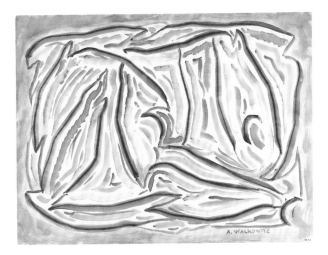

9.

Abraham Walkowitz,

Untitled (Abstraction),

1918, watercolor and

charcoal on paper,

Long Beach Museum

of Art, Gift of Gertrude

V. Whitney, 1959

Another subject that Walkowitz depicted throughout his career was the human figure. His penchant for rhythmic movement in the city is equally evident in the vast number of drawings he made over the years depicting, in motion, the dancer Isadora Duncan, whom he had met in Rodin's Paris studio in 1906. Like O'Keeffe's nudes, many of Walkowitz' renditions of Duncan in line and wash were influenced by this highly esteemed sculptor's drawings. In a statement published in the catalogue for the landmark 1916 Forum exhibition, Walkowitz noted that in his work he was aiming for line and color that are "alive with the rhythm which [he] felt in the thing that stimulated [his] imagination and [his] expression."[47] Walkowitz is only one of several artists associated with Stieglitz—notably, Hartley, Demuth, Marin, O'Keeffe—who wrote cogently, often extensively, about his or her work.[48]

CHARLES DEMUTH

Demuth (1883–1935), as a young artist, was as inclined toward writing as he was toward painting, though he eventually turned his focus to the latter. Demuth's works on paper are as important to his oeuvre as Marin's are to his. Indeed, on the basis of their work in this medium, the two men were considered "the most important figures in contemporary American painting."[49] Like Marin, Demuth also worked in oil throughout his career, especially after 1920, when he preferred oil or tempera for his important industrial subjects. Demuth's subjects on paper included landscapes, still-life and floral compositions, the architecture of his native Lancaster (where he remained

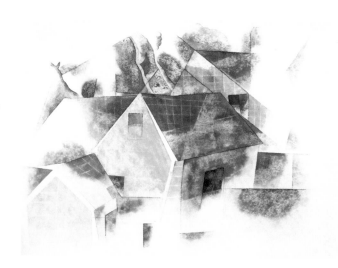

at least a part-time resident throughout his life), and the region's fertile farmland.
He also created figurative narratives rooted in vaudeville, jazz clubs, men's baths,
and literary texts such as Émile Zola's *Nana* and Henry James' *The Turn of the Screw.*

While Demuth's loose watercolors of the early teens reveal his admiration for
Marin's work, the tautness of his form starting in 1916 suggests that Cézanne's late
watercolors had become of primary importance. Demuth undoubtedly was familiar
with Cézanne's work and probably saw a show of the French artist's watercolors at
the Montross Gallery in January of that year. In Demuth's 1917 *Red-Roofed Houses*
(fig. 10), for instance, delicate graphite lines blocking in the essential architectural
geometry are interwoven with suggestions of lyrical foliage; both elements are
heightened by delicately textured washes. This watercolor is an early signal of the
precisionist style that was also embraced by Charles Sheeler and others.

Demuth's work was shown, not at 291, but at New York's Daniel Gallery. And
he was closely aligned with the artistic circle of the collectors Louise and Walter
Arensberg, which included Marcel Duchamp, who wrote of Demuth's importance
to American modernism in 1949: "His work is a living illustration of the disappear-
ance of a 'Monroe Doctrine' applied to Art; for today, art is no more the crop of
privileged soils, and Demuth is among the first to have planted the good seed in
America." [50] However, Demuth's close association with Stieglitz and O'Keeffe dates
back to the teens, and his art was the subject of several solo shows at The Intimate
Gallery and An American Place. Among Demuth's foremost collectors during his

lifetime was the eccentric Pennsylvanian, Dr. Albert C. Barnes. When the artist died, he left his paintings to O'Keeffe for distribution. Thus a substantial body of his work was included with the Stieglitz bequest. He left his watercolors to his lifelong friend, artist Robert Evans Locher of Lancaster, Pennsylvania.

• • •

American art of the twentieth century has been, in many ways, a wrestling match between representation and abstraction. A close comparison of the approaches taken by modernists in the Stieglitz circle and of those taken by artists working after World War II would certainly yield fascinating similarities and differences.[51] As Fairfield Porter suggested about O'Keeffe in 1955:

It has been pointed out long ago that Georgia O'Keeffe is a realist, and what made this statement original at the time was that it was made when she was painting abstractions. Now that she is not painting many abstractions, it may be valuable to point out the abstract quality of her realism....*From the Plains*...has the scale of emptiness and Romanticism that is seen in different ways in the work of such native Westerners as [Clyfford] Still and [Ad] Reinhardt. And her division of space in *In the Patio* has in it some of the design of [Mark] Rothko. These painters may or may not have been influenced by O'Keeffe, but she did come first, and our present familiarity with these painters should help us to see O'Keeffe's work freshly again, with its sense of the immensity of space.[52]

O'Keeffe and others in the Stieglitz circle lived and worked into the late twentieth century, a period when abstract expressionism was triumphant, followed by pop art, minimalism, and other approaches unknown at the start of their careers. Yet the importance of drawing—as summarized by Canaday in his 1964 editorial that is as true today as it was then—has remained constant:

[Because] abstraction has made the identification of form with expression so nearly complete...drawing has become an even more intimate and decisive act than it was when figurative images told so much of the story....Drawings remain the most immediate revelation of the impulses that force the artist into expression. The impulses are more varied, their expression is more fragmentary, technical experiments are extreme on the basis of "Let's try it anyway, and see if it works." But drawings still hold the essence of art in its contemporary manifestations.[53]

1 The phrase "thoughts without words," is taken from "Inner Distance," a late poem by Marsden Hartley in *The Collected Poems of Marsden Hartley 1904–1943,* Gail R. Scott, ed. (Santa Rosa, Calif., 1987), 232.

2 For the purposes of this essay, when the term "drawing" is used alone, it is meant to include work in pastels and watercolors as well as in graphite, charcoal, ink, and combined media.

3 John Canaday, "Editorial: On Drawings," *Art in America* 5 (1964), 21. The use of the pronoun "he" is gender specific language indicating that Canaday and others assumed "an artist" would be male; this usage also suggests the male-dominated environment in which O'Keeffe's reputation was established.

4 When Stieglitz died in 1946 it fell to O'Keeffe to organize and to begin to distribute his estate, which she did from 1946 through 1949, ably assisted by Doris Bry. Information about gifts from the estate is documented in notebooks compiled by Bry that are now housed at the Georgia O'Keeffe Foundation, Abiquiu, New Mexico. Excluding those books that record distributions of Stieglitz's photographs, these records are divided into two categories—"Foreign" and "American"—indicating the origin of the artist, although total consistency is not maintained in this respect. According to these documents, the five institutions that received works (other than photographs by Stieglitz) in the 1949 distribution were the Art Institute of Chicago; Carl Van Vechten Gallery, Fisk University, Nashville; the Metropolitan Museum of Art, New York; National Gallery of Art, Washington; and Philadelphia Museum of Art.

5 An American Place remained open until 1950 through the efforts of O'Keeffe and Stieglitz's protégé, Dorothy Norman.

6 *Camera Work* (April 1907). Quoted in Leigh Bullard Weisblat, "Kindred Spirits: A Chronology," in *In the American Grain: The Stieglitz Circle at the Phillips Collection* [exh. cat., The Phillips Collection] (Washington, 1995), 173.

7 Interest in the expressive possibilities of primitivism among 291 thinkers is explored at length in Judith Katy Zilczer, *The Aesthetic Struggle in America, 1913–1928: Abstract Art and Theory in the Stieglitz Circle* (Ph.D. diss., University of Delaware, 1975), 123–254.

8 A comprehensive list of exhibitions mounted at 291 can be found in William Innes Homer, *Alfred Stieglitz and the American Avant-Garde* (Boston, 1977), Appendix 1, 295–298. In appendices to the 1990 edition of *Alfred Stieglitz: An American Seer* (New York, 1960), 200–208, Dorothy Norman provides a listing of exhibitions that Stieglitz organized from 1905–1946.

9 Steichen and Rodin had first met in 1901. For a lengthy discussion of their relationship, see Penelope Niven, *Steichen: A Biography* (New York, 1997).

10 *Camera Work* 22 (1908). "The Rodin Drawings at the Photo-Secession Galleries," reprinted in *Camera Work: A Critical Anthology,* edited with an introduction by Jonathan Green (New York, 1973), 142.

11 O'Keeffe would also have seen Rodin drawings reproduced in the *Camera Work* April–July 1911 double issue. Further testament to her appreciation of Rodin is the presence in her library of Octave Mirbeau's *Le Jardin des supplices,* which Rodin illustrated with delicate drawings. The volume was printed by the superb lithographer Auguste Clot and published in 1902 by the art dealer Ambroise Vollard. For information on this and other holdings of her library see *The Book Room: Georgia O'Keeffe's Library in Abiquiu* [exh. cat., The Georgia O'Keeffe Foundation at the Grolier Club] (New York, 1997).

12 The point was made by Bernice Rose, *Drawing Now* [exh. cat., The Museum of Modern Art] (New York, 1976), 9, as part of a historical overview of the art of drawing. Rose suggested that to a large extent (and excepting collage) artists working today employ the same drawing techniques as those used by artists working in the fifteenth century. Although O'Keeffe was not included, the exhibition presented a range of work that was being done in the United States toward the end of her life.

13 See Sarah Greenough's brochure accompanying the 1993 National Gallery of Art exhibition *Stieglitz in the Darkroom.*

14 Like all works of art, drawings are most fully comprehended if one considers the materials of which they are composed and the manner in which those materials are used as thoroughly as one considers the subjects depicted.

15 For a useful discussion of different kinds of drawings, see Philip Rawson, *Drawing* (London, 1969), 283–316.

16 Quoted in Dorothy Norman, "Writings and Conversations of Alfred Stieglitz," *Twice a Year* 1 (fall–winter 1938), 79.

17 Homer 1977, 293, note 24; and
 *Somehow a Past: The Autobio-
 graphy of Marsden Hartley,* edited
 with an introduction by Susan
 Elizabeth Ryan (Cambridge, Mass.,
 1997), 61.

18 For recent writings on the water-
 color and pastel revivals following
 the Civil War, see Doreen Bolger
 et al., *American Pastels in the Met-
 ropolitan Museum of Art* [exh. cat.,
 The Metropolitan Museum of Art]
 (New York, 1989); Christopher
 Finch, *American Watercolors* (New
 York, 1986); Linda S. Ferber and
 Barbara Dayer Gallati, *Masters of
 Color and Light: Homer, Sargent
 and the American Watercolor Move-
 ment* [exh. cat., Brooklyn Museum
 of Art] (Brooklyn, N.Y., 1998);
 *American Impressionism and Real-
 ism: The Margaret and Raymond
 Horowitz Collection* [exh. cat.,
 National Gallery of Art] (Washing-
 ton, 1998); and Melanie Kirschner,
 "Pastel and Watercolor Revivals
 in the United States," in *Arthur Dove:
 Watercolors and Pastels* (New York,
 1998), 20–28.

19 Early exhibitions of O'Keeffe's
 work are recorded in Barbara Buhler
 Lynes, "Selected Exhibitions,"
 in *Georgia O'Keeffe: Catalogue
 Raisonné* (London and New Haven,
 1999).

20 Quoted in Marilyn Kushner, "The
 Introduction of Modern Watercolor
 to America," in *The Modernist
 Tradition in American Watercolors,
 1911–1939* [exh. cat., Mary and
 Leigh Block Gallery] (Northwestern
 University, Chicago, 1991), 10.

21 Dianne H. Pilgrim, "The Revival
 of Pastels in Nineteenth-Century
 America: The Society of Painters
 in Pastel," *American Art Journal*
 10 (November 1978), 26, as quoted
 by Nicolai Cikovsky Jr. in *Ameri-
 can Impressionism and Realism*
 1998, 63.

22 Lewis Mumford, Waldo Frank,
 Dorothy Norman, Paul Rosenfeld,
 and Harold Rugg edited *America
 and Alfred Stieglitz: A Collective
 Portrait* (Garden City, N.Y., 1934),
 published on the occasion of
 Stieglitz's seventieth birthday. Mum-
 ford's essay, titled "The Metro-
 politan Mileau," describes changes
 in New York City during "the
 period of Alfred Stieglitz's birth and
 education and achievement" (page
 38) and details how the city func-
 tioned as a foil for his photographic
 imagination.

23 *Composition* was issued in thirteen
 editions before 1931. A new edition
 was published in 1997 by the
 University of California Press, with
 an introduction by Joseph Mashek.
 The quotation is from this edition,
 page 67.

24 Rawson 1969, 284.

25 Entitled *Japan und Ostasien in der
 Kunst,* "it featured paintings, wood
 block prints and sculpture, as well
 as crafts and books," according to
 Helen Westgeest. See "West Looks
 East: A Short History" in her *Zen
 in the Fifties: Interaction in Art
 between East and West* (Zwolle,
 1996), 27–41.

26 The complete text of *Concerning
 the Spiritual in Art* was translated
 into English by Michael T.H. Sadler
 and published under the title *The
 Art of Spiritual Harmony* in 1914.
 Dover Publications, Inc., New York,
 issued a reprint entitled *Concerning
 the Spiritual in Art* in 1977.

27 Gertrude Stein to Alfred Stieglitz,
 undated [1913], Yale Collection
 of American Literature, Beinecke
 Rare Book and Manuscript Library;
 quoted in Ryan 1997, 18.

28 Kandinsky 1977, 19.

29 Homer 1977, 175.

30 On De Zayas, see Wendy Wick
 Reaves, "Marius de Zayas: Spot-
 light on Personality," in *Celebrity
 Caricature in America* [exh. cat.,
 National Portrait Gallery] (Wash-
 ington, 1998), 72–102.

31 Frances M. Naumann has recently
 edited and written an introductory
 essay for De Zayas' *How, When,
 and Why Modern Art Came to New
 York* (Cambridge, Mass., 1996),
 a text that Naumann dates to the
 late 1940s.

32 Reaves in *Celebrity Caricature in
 America* 1998, 85.

33 See Sheldon Reich, *John Marin:
 A Stylistic Analysis and Catalogue
 Raisonné,* 2 vols. (Tucson, 1970).

34 Marin's use of watercolor was
 more extensive and varied than
 O'Keeffe's; this is only one example
 of his methodology in this medium.

35 Reprinted in *Camera Work* 42–43
 (April–July 1913), 18.

36 See *The Eye of Duncan Phillips:
 A Collection in the Making*
 [exh. cat., The Phillips Collection]
 (Washington, 1999).

37 Little has been written about Hart-
 ley's works on paper. Exceptions are
 *Marsden Hartley Pastels: The Ione
 and Hudson Walker Collection* [exh.
 cat., University Art Museum, Uni-
 versity of Minnesota] (Minneapolis,
 1986), with an essay by Robert
 Gambone documenting eighteen pas-
 tels in that collection. Also see
 William J. Mitchell, *Ninety-Nine
 Drawings by Marsden Hartley (1877
 –1943): From Its Marsden Hartley
 Memorial Collection* [exh. cat.,
 Bates College, Treat Gallery] (Lewis-
 ton, Maine, 1970). According to
 the catalogue introduction, this col-
 lection, donated to Bates College
 in 1951, represents the last remain-
 ing effects from Hartley's Corea,
 Maine, studio. It includes works in
 pen and ink, graphite, and litho-
 graphic crayon, but not in pastel or
 watercolor. Our thanks to Genetta
 McLean, director of the Olin Art
 Center at Bates College, for discus-
 sing this collection with us.

THOUGHTS
WITHOUT WORDS:
O'KEEFFE
IN CONTEXT

38 Quoted in *Marsden Hartley: A Retrospective Exhibition* [exh. cat., Bernard Danenberg Galleries, Inc.] (New York, 1969), 31, reprinted from "Art and the Personal Life" in *Creative Art* 2, no. 6 (June 1928), xxxi–xxxvii.

39 For further discussion on similarities between Dove and O'Keeffe, see Susan Fillin Yeh, "Innovative Moderns: Arthur G. Dove and Georgia O'Keeffe," *Arts Magazine* (June 1982), 68–72.

40 The group of pastels that has come to be called The Ten Commandments has been considered by William Innes Homer in "Identifying Arthur Dove's 'The Ten Commandments,'" *The American Art Journal* (summer 1980), 21–32. See also Debra Bricker Balken, "Continuities and Digressions in the Work of Arthur Dove from 1907–1933," in *Arthur Dove: A Retrospective* [exh. cat., The Addison Gallery of American Art, Phillips Academy] (Andover, Mass., 1997), 17–24.

41 Homer 1977, 236. O'Keeffe recounted in a 1972 interview with the author that she was so impressed with the work by Dove that after she saw it she "trekked the streets looking for others."

42 Arthur Jerome Eddy, *Cubists and Post-Impressionism*, 2d ed. (Chicago, 1919), 48.

43 In her recent publication, *The Great American Thing: National Identity and American Culture, 1915–1935* (Berkeley, 1999), Wanda Corn addresses with penetrating insight the question of the "Americanness" of American art. Focusing on the early modernists, Corn paints a vivid picture of the lively artistic debates of the 1920s that sought, as Corn writes, to define "What was 'ours' and what was 'theirs.'" The authors wish to thank Professor Corn for providing an advance copy of this important addition to the literature of American art, and for reading a draft of this essay.

We also would like to thank Charles Brock, research associate for exhibitions at the National Gallery, for his timely responses to several queries.

Issues relating to American abstract art by later generations, schooled after surrealism took hold in the United States, require different arguments, which remain outside the scope of this essay. However, we would like to note in passing that the notion of American artists' attachment to the visible world has not held firm in post–World War II art.

44 Paul Rosenfeld, "American Painting," *The Dial* (December 1921), 665–667.

45 For further discussion of these works, see Charles C. Eldredge, *Arthur Dove: Small Paintings* [exh. cat., American Federation of Arts] (New York, 1997).

46 Kent Smith, *Abraham Walkowitz: Figuration, 1895–1945* [exh. cat., Long Beach Museum of Art] (Long Beach, Calif., 1982), 32.

47 Quoted in Abraham A. Davidson, *Early American Modernist Painting, 1910–1935* (New York, 1981), 38.

48 See Barbara Haskell, "The Artist as Writer," in *Charles Demuth* [exh. cat., Whitney Museum of American Art](New York, 1987), 35–47. For Hartley, see his autobiography (Ryan 1997); for Marin, see Dorothy Norman, ed., *The Selected Writings of John Marin* (New York, 1949); for O'Keeffe, see Georgia O'Keeffe, *Some Memories of Drawings,* Introduction by Doris Bry (New York, 1974) and *Georgia O'Keeffe* (New York, 1976).

49 A.E. Gallatin, *Charles Demuth* (New York, 1927), quoted in Betsy Fahlman, *Pennsylvania Modern: Charles Demuth of Lancaster* [exh. cat., Philadelphia Museum of Art] (Philadelphia, 1983), 17.

50 The Arensbergs donated their collection, including many works by Duchamp, to the Philadelphia Museum of Art. Marcel Duchamp, "A Tribute to the Artist," in *Charles Demuth* [exh. cat., The Museum of Modern Art] (New York, 1950), 17.

51 A European perspective on this subject, with O'Keeffe as the single representative of American modernism, is *The Birth of the Cool: American Painting from Georgia O'Keeffe to Christopher Wool* [exh. cat., The Kunsthaus Zurich] (Zurich, 1997).

52 In *Fairfield Porter: Art in Its Own Terms, Selected Criticism 1935–1975*, edited and with an introduction by Rackstraw Downes (New York, 1979), 179–180.

53 Canaday 1964, 21.

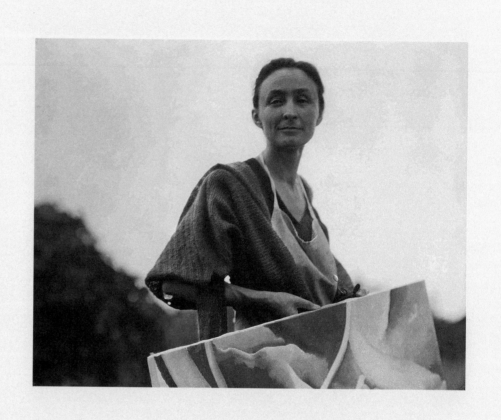

Inventions of
Different Orders

BARBARA BUHLER LYNES

From its very first showing in New York in 1916, the work of Georgia O'Keeffe has generated controversy. Over the years O'Keeffe tried to set the story straight and often refuted critical opinions by offering her own explanation of the genesis of the ideas underlying her art. Throughout her career, she consistently emphasized the importance of events in three early years—1908, 1912, and 1915—and, thus, attempted to provide a structure for understanding how her work developed.[1] In these accounts, she described her decision to abandon making art in 1908; her renewed interest in 1912 through the assimilation of ideas that ran counter to her previous training; and her subsequent rejection in 1915 of most of what she had been taught in order to achieve a personal means of expression that informed the remainder of her career.

Several changes took place in O'Keeffe's imagery after 1912, however, that suggest a slightly different and more complex version of the story of the evolution of her art, both in terms of the materials she used and the effects she was attempting to achieve through their manipulation. An examination of the few known works surviving from 1908–1914 that set the stage for these changes and of the works in the exhibition that reveal the direction her art seems to take after 1915 provides a new framework for understanding the artist's early development and subsequent achievement.

In 1908, after a year of study at the Art Students League, the twenty-one-year-old O'Keeffe won the league's William Merritt Chase still-life prize for *Untitled (Dead Rabbit with Copper Pot)* (fig. 1). Although the award clearly affirmed O'Keeffe's accomplishment, she abandoned her childhood dream of making her way as an artist within several months of receiving it. She later explained the motivation for her decision: "In school I was taught to paint things as I saw them. But it seemed so stupid! If one could only reproduce nature, and always with less beauty than the original, why paint at all?"[2] She moved to Chicago, where she worked in commercial art until 1910, when she became ill and went to Charlottesville, Virginia, to live with her family.

In Virginia in 1912 O'Keeffe found an entirely new way of thinking about art that rejuvenated her earlier interest. Through Alon Bement, who was teaching that summer at the University of Virginia, she discovered the ideas of his associate, the artist and educator Arthur Wesley Dow, who was then head of the art depart-

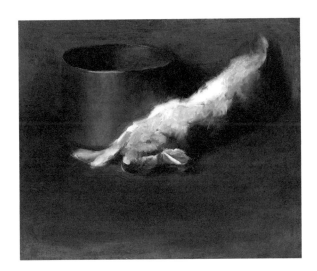

1.

Untitled (Dead Rabbit with Copper Pot), 1908, oil on canvas, The Permanent Collection of the Art Students League, New York

ment at Teachers College, Columbia University. She attended Bement's course, where she learned a means of conceptualizing art that was not based on the tradition of imitative realism that had formed the core of her previous art education at the Art Institute of Chicago and the Art Students League.[3] To Dow, artistic expression was, above all, a *personal* expression that was best realized by thinking of art as a visual harmony achieved not through imitation but through design—a synthesis of line, color, and the Japanese conception of *notan* (tonal contrasts). His ideas appealed to O'Keeffe, who later pointed out: "This man [Dow] had one dominating idea; to fill a space in a beautiful way—and that interested me."[4] Bement also encouraged O'Keeffe to become aware of advances in European and American modernism. Moreover, he urged her to further her training in art, which she did in the fall of 1914 in New York at Teachers College, Columbia University.

Other than *Untitled (Dead Rabbit with Copper Pot),* no O'Keeffe works are known from 1908–1912, and only five works have been discovered that document her activity in 1912–1914, years when she first experimented with Dow's ideas.[5] However, the extent of what she produced during these years can never be known because O'Keeffe destroyed a number of works:

When I knew I was going to stay in New York [in 1918], I sent for things I had left in Texas. They came in a barrel and among them were all my old drawings and paintings. I put them in with the wastepaper trash to throw away and that night when…I came home after dark the paintings and drawings were blowing all over the street. We left them there and went in.[6]

However, two of the surviving paintings from 1912–1914, *Untitled (Horse)* (fig. 2) and *Untitled (Catherine O'Keeffe)* (fig. 3), do suggest O'Keeffe's increasing awareness of European modernist movements (in these cases, post-impressionism and expressionism). Both works demonstrate that she had followed Bement's advice; indeed, it was in applying both Bement's and Dow's principles that O'Keeffe moved closer to the creation of an art that was her own. In 1915 she took another step toward this goal:

It was the fall of 1915 that I first had the idea that what I had been taught was of little value to me except for the use of my materials as a language....I hung on the wall the work I had been doing for several months....I could see how each painting or drawing had been done according to one teacher or another...and I decided to start anew—to strip away what I had been taught—to accept as true my own thinking....I began with charcoal and paper and decided not to use any color until it was impossible to do what I wanted to do in black and white. I believe it was June before I needed blue.[7]

That there is more truth in this statement than not is best demonstrated by O'Keeffe's charcoal experiments of 1915–1916, such as *Early No. 2* (cat. 3) and *First Drawing of the Blue Lines* (1916, National Gallery of Art). The astonishing

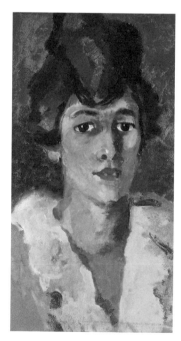

2.
Untitled (Horse), 1914,
oil on cardboard,
The Georgia O'Keeffe
Foundation, Abiquiu

3.
*Untitled (Catherine
O'Keeffe)*, c. 1912/1914,
graphite and oil on
paper, private collection

degree of abstraction displayed in these drawings has distinguished them as being among the most innovative works in early American modernism. It is also astonishing that they seem to have come directly from O'Keeffe's personal vision and are not directly related to any other modernist images of the period. At the same time, however, they reveal that despite her claim, O'Keeffe did find "value" in what she had learned over the years when she set out to define her own idiom. Her charcoal experiments attest to her debt to the fundamental objective of Dow's innovative theory—that self-expression, rather than the imitation of nature, is the goal of the artist.[8] And it was the intensely personal nature of these works that appealed to Alfred Stieglitz, the internationally known photographer and impresario of modern art, and gave him a basis for promoting O'Keeffe's art as archetypically American. Several months after seeing her works, he included ten in a group show at his gallery, 291, in May 1916.[9]

But from the beginning Stieglitz promoted O'Keeffe primarily as a woman artist—one whose modernist vocabulary was intuitively derived—and secondarily as a specifically American artist whose imagery was free of the influence of her European contemporaries. This conception of O'Keeffe complemented her own claims of having determined in 1915 to abandon almost all aspects of her previous training and to pursue an imagery expressive of herself alone, a position she continued to advocate until her death in 1986.[10] But in addition to the charcoal abstractions of 1915–1916, other works on paper made from 1915–1918 demonstrate not only her commitment to the discovery of a personal language but also her selective use of many elements of her previous training.[11]

The sixteen known drawings dating from 1915–June 1916 substantiate O'Keeffe's assertion of having worked exclusively with charcoal during this period. However, two pastel drawings—*Special No. 33* (fig. 4) and *No. 32—Special* (1915, National Museum of American Art, Smithsonian Institution)—were unequivocally made in 1915 (most likely in Virginia in the summer of that year). Though highly abstract, both works document a specific event, indicating that O'Keeffe had been working with the idea of expressing experience through abstraction before she began working in charcoal that fall. Moreover, the existence of these pastels implies that there may well have been more works in color in this medium from 1915–1916 that were subsequently lost or destroyed.

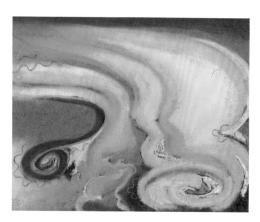

4.

Special No. 33, 1915,

pastel on paper,

private collection

In a letter written to her friend Anita Pollitzer shortly after the two pastels were made and in another written over sixty years later to the current owner of *Special No. 33,* O'Keeffe pointed out that in them she had observed and reduced forms in nature, a process she had come to understand through Dow. "[This] is Political Science [12] and me—dabbling our feet in the water—It is about fifteen feet deep right under our feet—is red from the red clay" (O'Keeffe to Anita Pollitzer, October 1915);[13] and "These abstractions were done after sitting on the edge of a river, and having a conversation with a friend about abstractions from nature. I went home and made two pastels to illustrate to him what I meant" (O'Keeffe to private collector, 1977). O'Keeffe's 1915 report of the inspiration for the drawings matches her 1977 account, suggesting that she was as clear late in life about the significance of these works as she had been in 1915. These pastels, like the works in charcoal begun later that year, demonstrate her commitment to her goal of realizing something that had specific meaning to her.

Black Lines (cat. 5) was completed in the spring of 1916 in New York, a period when O'Keeffe pursued additional course work at Teachers College. The drawing is one of a series of charcoals or watercolors that convey her response to the verticality of the city's skyscrapers that she could see from the window of her room.[14] Its elegant, reductive lines speak both to O'Keeffe's search for a personal imagery and to the flatness of the drawing's surface. At the same time, however, opposing verticals and horizontals combined with a single diagonal coexist harmoniously, an ample demonstration of O'Keeffe's sophisticated grasp of and continuing experimentation with Dow's theories of opposition in design.

In this and other works on paper that O'Keeffe made in New York or in 1916–1918 in Virginia or Texas (where she taught art according to the Dow method at the University of Virginia and at West Texas Normal State College in Canyon), there is a continuing sense of her having set out to achieve a personal, expressive imagery. But Dow's theory of artistic expression as primarily an arrangement of forms extracted from observation underlies all of her work of this period.

In *Blue II* (cat. 6), completed in the summer of 1916 in Virginia before O'Keeffe moved to Texas in August, the artist translated into watercolor the expressive movements and rhythms of her 1916 charcoal drawing *No. 8—Special* (fig. 5). The 1916 *Blue No. II* and *Blue No. III* (cats. 7, 8) state and repeat the cornucopia shape found in *Blue II* and offset it with repeating diagonals. Although these works do not suggest environmental subject matter or a sense of pictorial space, the images, like the 1915–1916 charcoal abstractions and the earlier *Black Lines*, were very likely grounded in O'Keeffe's visual environment. In *Blue Hill No. I*, *Blue Hill No. II*, and *Blue Hills No. III* (cats. 9–11), also completed in 1916 in Virginia, O'Keeffe began to flood wet paper with pure pigment to establish broad planes of transparent color that suggest landscape forms. As colors pool and puddle in these paintings, they foreshadow her interest, which would develop over the next few years, in exploring watercolor as a fluid medium.

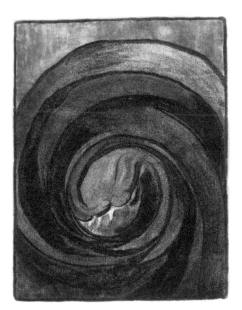

5.

No. 8—Special, 1916, charcoal on paper, Whitney Museum of American Art, New York, Purchase, with funds from the Mr. and Mrs. Arthur G. Altschul Purchase Fund

After her move to Texas in the fall of 1916, her palette broadened and her subject matter references became more pronounced in works like *Roof with Snow* (cat. 12), *Hill, Stream and Moon* (cat. 22), and *Train at Night in the Desert* (cat. 13). *Evening Star No. V* (cat. 21) is an extraordinarily sophisticated, nontraditional handling of the medium and a remarkable document of O'Keeffe's increasing interest in controlling the degree of abstraction in her work. Part of a series of eight watercolors, *Evening Star No. V* establishes an interlocking series of rhythmic shapes that interact on the surface to express almost perfectly Dow's principle of extracting elements from the environment and arranging them dynamically. At the same time, however, it expresses O'Keeffe's personal delight in the drama of the early night sky in Texas.

Stieglitz included twenty-three works in O'Keeffe's first one-person exhibition in New York in April 1917: seven charcoals, ten watercolors, and six oil paintings.[15] Several works in *O'Keeffe on Paper*, including *Black Lines, Blue No. II, Blue No. III,* and *Train at Night in the Desert,* are similar to those Stieglitz showed in 1917. But in contradistinction to the idea, implied by O'Keeffe and promoted by Stieglitz, that her work was entirely intuitively realized, certain works in the 1917 exhibition, such as the oil paintings *No. 24—Special/No. 24* (fig. 6) and *No. 22 Special* (1916/1917, Georgia O'Keeffe Museum), reveal O'Keeffe's awareness of and interest in the work of European modernists and in the work of at least one of the artists that Stieglitz supported, Arthur Dove.[16]

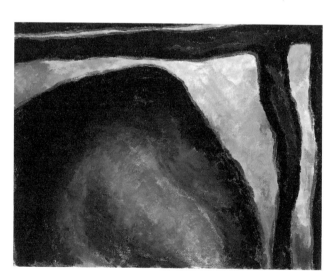

6.

No. 24—Special/No. 24,
1916/1917, oil on canvas,
The Georgia O'Keeffe
Foundation, Abiquiu

The work O'Keeffe produced during the summer of 1917, after her exhibition, also continues to suggest affinities with the work of other artists of the period, including those whose art was exhibited at Stieglitz's galleries or reproduced in his magazine *Camera Work*.[17] Three O'Keeffe watercolors from this period, though highly abstract, are portraits of photographer Paul Strand, whom she had met earlier that year in New York: *Untitled (Abstraction/Portrait of Paul Strand)* (cats. 17–19). The fluidity and expressiveness of these works are typical of the way O'Keeffe had been thinking of watercolor. As early as 1915 she had experimented with abstract "portraits," claiming that her thoughts about people could be expressed more clearly visually than verbally. However, she may have been inspired to continue this conception of portraiture through her awareness of similar experiments by other artists, such as Francis Picabia and Marius de Zayas, whose abstract portraits had been published by Stieglitz in the October 1914 issue of *Camera Work*.[18] And the strong correlation between O'Keeffe's 1917 nude self-portraits in watercolor, such as *Nude Series XII* (cat. 16), and the drawings by Auguste Rodin that she had seen several years earlier, in 1908 at 291 and in the April–July 1911 issue of *Camera Work,* has been well established.[19] Other sketches from this period, such as *Untitled (Still-Life)* (fig. 7), demonstrate her awareness of cubist ideas— such works by Pablo Picasso had been reproduced in the October 1911 and August 1912 issues of *Camera Work*. Therefore, it seems clear that O'Keeffe had begun to broaden her horizons more than has been thought.

But in the watercolors she produced in San Antonio in early 1918, O'Keeffe began to move away from the fluid handling of the medium that characterizes her watercolors from 1917, and descriptive, environmental subject matter became a

more significant component of her imagery. She continued to use color expressively, but she turned to the architectural and figural forms of the city's market as subjects. In *Window — Red and Blue Sill* (cat. 24), for example, intense, heightened colors describe a series of interlocking architectural shapes, while in *Three Women* (cat. 25), O'Keeffe introduced essentially unmodulated, broad patches of color that, through their size differences, suggest figures in space. At the same time, however, she denied that spacing by leaving a linear pattern of unpainted paper between the shapes that structure the composition.

On the other hand, in *Woman with Blue Shawl* (cat. 26) O'Keeffe seems to have approached the subject matter very differently. The figure is slightly modeled in terms of light and dark, as are some of her 1917 nude self-portraits, such as *Nude No. III* (cat. 15), but the woman is also situated in a shallow, receding space by the use of a ground shadow. These elements in combination, though extremely subtle, are rather startling in O'Keeffe's vocabulary at this time. They are imitative devices for establishing forms within space that can be associated with the traditional training that she had received before 1908 and claimed to have abandoned in 1915.

Almost as soon as O'Keeffe moved from Texas to New York in June 1918, such traditional elements increasingly characterized her work, as she turned away from watercolor, which had been her primary medium for two years, and worked in charcoal, pastel, and, dominantly, in oil. Known surviving works indicate that

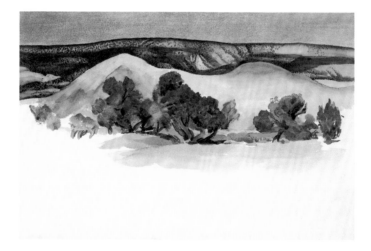

8.
Untitled (Ghost Ranch Landscape), c. 1936, watercolor on paper, Georgia O'Keeffe Museum, Gift of The Burnett Foundation

whereas she produced 111 watercolors from 1916–June 1918, in the next two years, she produced only 10. Moreover, only 10 known watercolors date from the 1920s, and only 36 date from 1930 to the mid-1970s. And with the exception of the 1919 *Blue Shapes* (cat. 31), whose interlocking geometric shapes establish non-descriptive, flat forms that overlap within a limited space, her watercolors after 1918 return to more traditional methods. For example, in *Untitled (Ghost Ranch Landscape)* (fig. 8) of c. 1936, O'Keeffe used lights and darks to establish volumes that are situated within a descriptive, fictive space containing foreground, middle ground, and background. Only in her 1976–1979 series of 45 watercolors, including *Red Line with Circle* (fig. 9), which the nearly blind artist completed with assistance, did O'Keeffe again use watercolor as a vehicle to explore an abstract idea. The simple shapes in these works respect the flatness of the picture plane and, thus, recall the character of some of her earliest experiments in abstraction in 1915–1916.

Either O'Keeffe's exploration of watercolor as a means to achieve the expressive ideas she sought beginning in 1915 was exhausted by 1918 or those ideas changed dramatically after her move to New York. It is more likely that her ideas changed, a theory that is substantiated by her subsequent works on paper in other

9.
Red Line with Circle,
1976/1977, water-
color on paper,
private collection

media. In *Over Blue* (cat. 27), for example, O'Keeffe's use of pastel is so different from her 1915 methods that it is difficult to believe the earlier and later works are by the same hand. With *No. 32—Special*, 1915, the medium establishes abstract forms contiguous with the picture plane and expressive of O'Keeffe's decision of that year to discover a particular language for conveying her own ideas and feelings. In addition, in the 1915 work, her marks clearly reveal the nature of the chalk she was using. Beginning in 1918, however, she applied pastel as if it had the plasticity of paint, blending it to attain a degree of surface finish that has no relationship to her work in any medium from 1915–June 1918.

In *Over Blue* (as with most of the watercolors she produced from 1918 to the mid-1970s), forms are more than shapes; they are volumes—an effect that she accomplished through the careful control of lights and darks. Abstraction was a key component of her pictorial language either directly, such as in *Over Blue,* or in the relationships she established between highly simplified natural forms (*Blue Flower,* cat. 28). However, with a few exceptions in this period, O'Keeffe was apparently more intent on establishing a kind of abstract illusionism by juxtaposing modeled forms within compositions that do not explore the relationship of these forms to their environments. Two exceptions are from 1922: *Lightning at Sea* (cat. 34) and *Pond in the Woods* (cat. 36); both works are in all senses more diagrammatic than illusionistic, though the degree of abstraction remains high.

Two pastels of 1923, *Alligator Pear* (cat. 37) and *Alligator Pears* (cat. 38), are an excellent demonstration of the polarity of O'Keeffe's thinking during this period. In one (cat. 38), the subject matter is secondary to the composition: the avocado form is embedded in a dynamic composition of curves and diagonals that are modeled and describe a landscape as well as a still-life setting. The other (cat. 37) is a tour de force: a carefully modeled form is situated in an illusory, though highly limited, environmental space.

By the second half of the 1920s, in *East River* (cat. 41) O'Keeffe had turned even further away from her early impulse to abstraction and had begun to establish a relatively palpable space in which simplified, though instantly recognizable, forms exist in an atmosphere permeated with aerial perspective and controlled spatially by their relative sizes in receding planes. But an uneasy coexistence of abstraction and illusionism marks O'Keeffe's work in pastel through the 1940s. This dichotomy

10.

Untitled (From a Day with Juan), 1976/1977, pastel on paper, The Georgia O'Keeffe Foundation, Abiquiu

prevails either from work to work, for instance, from *The Shell* (cat. 45) of 1934, to the 1943 *Untitled (Beauford Delaney)* (cat. 51), or within the same work, for example, in *The Black Place III* (cat. 52) of 1945. After 1945, the only extant pastel is a drawing from 1976/1977, *Untitled (From a Day with Juan)* (fig. 10), which though based on an architectural form, is one of the most simplified, abstract images of her mature career.

O'Keeffe's work in charcoal after 1918 developed in a similar manner. In the 1919 *Black Lines* (cat. 29), for example, she presented two sharp-edged, unmodulated diagonals that dramatically affirm the surface of the paper support; but their flatness is contradicted by the treatment of the plane in front of which they appear to exist: its termination conveys a sense of volume. In later works based on views of the city, such as the 1926 and the more reductive 1932 *Untitled (New York)* (cats. 40, 42), she used incidental diagonals and contrasts of lights and darks in interacting planes to establish limited spaces in which highly flattened forms exist. The compositions of both drawings resolve well inside the delimitation of the edges of their supports, revealing yet another dimension of O'Keeffe's continuing debt to Dow.

Other works in charcoal from the 1930s–1950s, including *Kachina* (cat. 43) and *Untitled (Banana Flower)* (cat. 44), demonstrate O'Keeffe's virtuosity in manipulating lights and darks in order to create forms that demand recognition as volumes. But in the case of these and similar works, such volumes coexist ambiguously and often uneasily with their pictorial environments, which are defined solely by their two-dimensional paper supports. She diverged from this approach only rarely: in *Brooklyn Bridge,* (cat. 53), for instance, the subject matter invited a mark-making technique, rather than a modeled, volumetric approach to form. And these marks, though in this case guided by the configurations of a highly recognizable architectural form, evoke her obvious delight in mark-making from the teens.

In 1959/1960, during the first of her world travels, O'Keeffe was inspired by views of the earth, which she observed from the window of an airplane. She made a series of charcoal drawings, such as *Drawing V* (cat. 54), in which most of the abstract forms read as flat shapes and patterns on the surface. Her treatment of subject matter in these relatively late works recalls a flattening trend that surfaced from time to time in her career (notably in the Patio series of the 1940s and 1950s); this trend can be said to have its origins in many of the works she made in the fall of 1915. And the latest drawing in the exhibition, *From a River Trip* (cat. 55) of 1965, also depends on shapes, rather than volumes, to describe natural forms, but situates the forms within a shallow, receding foreground. To the end, O'Keeffe's work contained a mixture of approaches to the delineation of form and space.

From June 1918 to the late 1950s, O'Keeffe produced 135 finished works in charcoal, pastel, or watercolor. When this number is compared to the 141 works on paper that she completed from the fall of 1915 to June 1918, it becomes clear that she elected to work on paper more frequently in three years in the teens than she did during the next forty. It is possible that O'Keeffe continued to produce as many works on paper after her arrival in New York in 1918 and that the bulk of these works is lost. But this supposition is based solely on the disparity in the number of drawings she produced. In any case, it is clear that her extant works on paper from the summer of 1918 and after show an approach to watercolor, pastel, and charcoal that is more about surface finish than about the apparently spontaneous directness that characterizes what she produced from 1915–June 1918. It is also clear that whatever produced this change in her conception of her work was meaningful enough to direct most of her subsequent imagery.

This is not to say that O'Keeffe was not inventive during her post-Texas career, but it was invention of a different order. For example, beginning in the mid-1920s she startled the New York art community with a completely new approach to flowers as subject matter, presenting them close-up in large formats. In the resulting works, this new treatment of subject matter, rather than a new approach to form or to a medium, allowed O'Keeffe to achieve the goal that she had first set in 1915: the expression of feelings and experiences that were highly personal. One of the later manifestations of this experiment is the 1941 pastel, *Narcissa's Last Orchid* (cat. 50). Despite its relatively modest physical size, O'Keeffe transformed the small, delicate, transitory flower into a monumental form that confronts the viewer with O'Keeffe's conception of nature as a strong, vibrant, vital force.

Also inventive, as a choice of subject matter, are O'Keeffe's images of New York; some have considered them the most successful by any artist in the period.[20] And since 1929, when she first began working in New Mexico, O'Keeffe chose the manipulation of subject matter (landscape, architecture, and found objects), rather than any other variable, as a device to represent her experience.

Finally, it is possible that the decline in the number of works on paper produced by O'Keeffe after her move to New York in 1918 may have been the result of her attempt to redefine herself as an oil painter, an idea that could well have been generated by Stieglitz's keen understanding of the New York art world. Despite the unparalleled success of the Stieglitz-supported John Marin as a watercolorist in the first half of this century, prowess in easel painting was still a measure of artistic accomplishment; for a woman who aspired to be taken seriously in this environment, it was probably a necessity. Indeed, from 1918 to the end of her career, O'Keeffe produced more than eight hundred works in oil, most of which reveal a degree of surface finish similar to that of *Over Blue,* the virtuosic pastel she made in 1918.

But precisely what made her decide to work primarily in oil after 1918, to abandon, in effect, the kind of innovation most characterized by her works on paper from 1915–1918, and to return to the techniques that she had mastered during her earliest academic training (before 1908) may never be known. Her available correspondence does not address why after June 1918 her work suddenly displays a degree of illusionism that distinguishes it markedly from her works on paper of the previous two and one half years. Indeed, O'Keeffe consistently retold the story

of how she had consciously freed herself from all aspects of her academic training before 1915. Although further research on the relationship between her works on paper and those in oil may reveal more about this profound change in the character of O'Keeffe's imagery after June 1918, it is unlikely that a reason for it will be discovered. For later that year, after her arrival in New York, O'Keeffe threw out works that may have provided clues.

1 See, in particular, Georgia O'Keeffe, *Some Memories of Drawings,* Introduction by Doris Bry (New York, 1974) and Georgia O'Keeffe, *Georgia O'Keeffe* (New York, 1976), unpaginated.

2 "I Can't Sing, So I Paint! Says Ultra Realistic Artist; Art Is Not Photography—It Is Expression of Inner Life!: Miss Georgia O'Keeffe Explains Subjective Aspect of Her Work," *New York Sun,* 5 December 1922, 22.

3 O'Keeffe attended the Art Institute of Chicago in 1905–1906.

4 Katherine Kuh, *The Artist's Voice: Talks with Seventeen Artists* (New York, 1960), 190.

5 From 1912–1914, she worked as supervisor of drawing and penmanship in the public schools in Amarillo, Texas; beginning in 1913, she assisted Bement in his classes at the University of Virginia during the summers.

6 See Bram Dijkstra, *Georgia O'Keeffe and the Eros of Place* (Princeton, 1998), 7.

7 O'Keeffe 1976, text accompanying entry 1.

8 In addition, the compositional premise of several of the drawings made in this period can be traced directly to Dow's theories. Moreover, the forms in these drawings have been related to those of the art nouveau and arts and crafts movements in America. For a discussion of these relationships, see Sarah Whitaker Peters, *Becoming O'Keeffe: The Early Years* (New York, 1991), 14, 41–51.

9 O'Keeffe reported how her work came into Stieglitz's hands in the statement published in the brochure for the exhibition that Stieglitz organized of her work in 1923. It is reprinted along with five other O'Keeffe statements that were also published in association with exhibitions of her art in Barbara Buhler Lynes, *Georgia O'Keeffe: Catalogue Raisonné* (London and New Haven, 1999), 1098.

10 See O'Keeffe 1974 and O'Keeffe 1976.

11 Because O'Keeffe uniformly sought ideas from her visual environment, it is important to the understanding of her imagery from 1915–1918 to realize that she worked in many different places, and the characteristics of each place had a bearing on the subjects that appear in her work —spring 1915: New York (Teachers College); fall 1915: South Carolina; spring 1916: New York (Teachers College); summer 1916: Virginia; fall 1916–winter 1918: Canyon, Texas; winter–spring 1918: San Antonio, Texas, environs; from spring 1918: New York.

12 "Political Science" is Arthur Whittier Macmahon, a professor of political science at Columbia University who met O'Keeffe while he was teaching summer courses at the University of Virginia in 1914. He taught there again in 1915 and visited O'Keeffe over Thanksgiving in November of that year.

13 See *Lovingly, Georgia: The Complete Correspondence of Georgia O'Keeffe and Anita Pollitzer,* Clive Giboire (New York, 1990), 48.

14 This information has been verified in the correspondence between Georgia O'Keeffe and Alfred Stieglitz, edited by Juan Hamilton and Sarah Greenough, publication of which is forthcoming.

15 Stieglitz photographs documenting all works in that exhibition are housed at the J. Paul Getty Museum, Los Angeles. They are reproduced in Lynes 1999, 1109–1111.

16 The low-key greens and browns of the vaguely organic and gridlike abstract shapes of *No. 24 — Special/No. 24* are reflective of the palette and forms in works of this period by Dove. The color in this work, as well as the preponderance of red and orange juxtaposed with greens and blacks in *No. 22 Special,* is used expressively rather than descriptively, a device characteristic of works of first-generation European expressionists; and the heavily brushed impastos in both works animate their surfaces in a way that owes much to certain aspects of post-impressionism. See William H. Gerdts, "The American Fauves: 1907–1918," in *The Color of Modernism: The American Fauves* (New York, 1997). For a discussion of influences on O'Keeffe, see Peters 1991, 81–123.

17 O'Keeffe received back issues of *Camera Work* from Stieglitz while she was in Texas (see note 14).

18 See *Alfred Stieglitz: Camera Work, A Pictorial Guide,* Marianne Fulton Margolis, ed. (New York, 1978), 133.

19 See Peters 1991, 109–112, 327, notes 97, 99, and Barbara Rose, "O'Keeffe's Originality," in *Georgia O'Keeffe Museum,* Peter H. Hassrick, ed. (New York, 1997), 102.

20 See Anna Chave, "'Who Will Paint New York?'" *American Art* 5 (winter/spring 1991), 87–107.

The Language of
O'Keeffe's Materials:
Charcoal, Watercolor, Pastel

JUDITH C. WALSH

Georgia O'Keeffe used her works on paper both to develop her imagery and to refine her aesthetic.[1] Exploring in sequence the inherent qualities of charcoal, watercolor, and pastel, she combined their strengths to create her own style. In charcoal she found seductive tonal values, in watercolor the emotional power and beauty of clear vibrant color, and in pastel the soft blending of color within a minimally textured surface—all qualities that also mark her paintings in oil. Her style can best be described as exquisite: whatever the imagery, and in whatever media, O'Keeffe's work of art is itself physically intimate and refined. Despite the clarity and strength of a work's graphic design or color scheme, its pristine surface appears to be delicate and fragile. Clear color and impeccable surface are critical and deliberate parts of her art. To carefully preserve them, she paid such close attention to technical matters that her work still bears few signs of aging.[2]

At the age of eighty-seven, O'Keeffe recalled how, beginning in 1915, she had determined to make her work original:

I first had the idea that what I had been taught was of little value to me except for the use of my materials as a language—charcoal, pencil, pen and ink, watercolor, pastel and oil. The use of my materials wasn't a problem for me. But what to say with them? I had been taught to work like others and after careful thought I decided that I wasn't going to spend my life doing what had already been done....I decided to stop painting, to put away everything I had done, and start to say the things that were my own.[3]

She started with charcoal. Cheap and almost intuitively used, charcoal is often the first artist material given to students. Using charcoal seems to have been a deliberate reenactment of her art training: "I am starting all over new—," she wrote to Anita Pollitzer.[4] Throughout O'Keeffe's career episodes of charcoal use mark new starts. She returned to charcoal in 1926, when she first examined the skyscrapers of New York, in 1934 after New York "broke" her, in 1959 after her first trips in an airplane, and finally in 1976 in Antigua and Big Sur when she courageously began to draw again despite her poor eyesight. Charcoal may have seemed in 1915, as at those other times, an old friend. She had first used it in drawing lessons as a schoolgirl, and later, as an art student.

Charcoal is made by heating sticks of willow or vine in a closed chamber from which the oxygen has been removed. Without oxygen the wooden pieces do not

burn; rather they are reduced to pure carbon and retain their natural morphology. Large chunks and small splinters of the carbon break off and are ground into the sheet or canvas by the pressure of the artist's hand. As the particles are held only by the texture of the support on which they lie, they can be completely and easily removed by rubbing with a soft eraser. The solid fragments can be smoothed into the sheet with a stomp (a rolled tube of soft paper with a pointed end), finger, or rag. Subtle tonal shifts and shadows are economically described by charcoal, and highlights are easily recovered.

Found in art throughout the ages—even in cave paintings—charcoal has been the tool of choice for underdrawing on panel and canvas painting. It was not used as an independent medium for exhibition work until the mid-nineteenth century in France, where a tonalist aesthetic found in charcoal the perfect medium for landscape, portrait, and genre drawings.[5] Daring practitioners such as Gustave Courbet and Odilon Redon exhibited finished charcoal drawings in the Salons, and these were pursued by collectors.[6] In America, a similar charcoal vogue was located around William Morris Hunt, who had studied in France with Thomas Couture and had introduced Jean-François Millet and contemporary French romanticism to Boston.[7] Hunt's dark and romantic charcoal drawings recommended the medium to American artists—including George Inness and John La Farge—who sought a mystical or emotional expressiveness in their work. Charcoal was, therefore, not just a familiar tool for O'Keeffe, but also a proven tool for the sorts of images she wanted to make, images that were personal, mystical, and full of feeling.

Charcoal drawing as practiced by O'Keeffe in the teens was a time-consuming and willful process. Until a fixative is applied, charcoal can be easily removed from a well-sized paper such as those O'Keeffe used.[8] The drawings could be worked and reworked for days, with no restriction on the number or extent of changes to a design. Entirely malleable, charcoal was a perfect tool for O'Keeffe to employ as she sought to develop a language that could adequately describe her imagination. Using the sticks in both traditional and new ways, she created some of the most important drawings of her career.

O'Keeffe's teaching schedule at Columbia, South Carolina, in 1915 gave her a great deal of free time. She had "Monday free and afternoons after 3" and could "get in at least 2 hours work...during school," using a private room off the class

studio.[9] She would go for long walks in the afternoon, then draw some more at night on the floor of her room, crawling around until she got "cramps in her feet." [10] Despite her familiarity with the material, and the luxury of time to explore its potential, O'Keeffe apparently struggled over these drawings. She characterized charcoal as "a miserable medium for things that seem alive—and sing." [11] Later she half jokingly complained,

I wish you could see the thing I made today—…it doesn't satisfy me…so I must work longer—Fancy me working a whole week—all my spare time doing the same thing over and over—I am beginning to think that by the time Whistler had worked for 62 sittings on the portrait they tell about—he would have been a pretty unlucky devil if he hadn't hit something fairly good in all that slaving on the same thing—[12]

The range of techniques O'Keeffe used in charcoal can be seen in *No. 7 Special* (cat. 2), which has been identified as one of the group of drawings presented to Alfred Stieglitz on 1 January 1916.[13] She dragged a short piece of charcoal on its side to create the broad lines at the center, while the sharpened point of a charcoal stick was used to make the dark outlines. In the midtones, she smudged the applied charcoal with a stomp, which filled the paper texture with pigment and created an even tone. In the broad lines that were not stomped or blended, she left the topography of the paper clearly visible, creating a dappled effect. The hard edges of the squares in the center were probably defined by lifting charcoal with an eraser. O'Keeffe also used charcoal to explore the formal problems of drawing. In 1916, she wrote of one problem she hoped to solve:

When we draw we try to make rhythms from right to left—up and down—that is, flat rhythms like—You know what I mean—we try to have rhythms running over the surface—why don't we try to make them feel as if they were coming and going to and from you—through the thickness of the paper as well—Maybe it is something everybody else has been trying to do—but I haven't felt exactly what I mean except in parts of pictures.[14]

For *Crazy Day* (cat. 30) from 1919, O'Keeffe, in a sophisticated use of charcoal, created a variety of tones and textures that seem to move deep into the picture plane. The ability to obtain the darkest blacks from charcoal was critical to her success.

Charcoal black is not a very dark or opaque black; it gives silvery tones when used in thin layers. Very dark blacks can only be achieved if a binder or fixative

holds thick deposits of material.[15] To get around this defect, artists soak charcoal sticks in oil and use them before the oil dries. "Oiled" charcoal, which has been in use since the Renaissance, makes dark marks that become impermeable. The pattern of slight yellow discoloration on *Crazy Day* suggests that O'Keeffe used a variation of the Renaissance technique. She apparently painted varnish on the sheet using a wide brush, then drew into it with her charcoal stick. She may have applied varnish to the sheet in anticipation of the drawing, but it is more likely that she sketched the composition first, then painted varnish on the reverse when she realized that dark lines in the foreground would be necessary.[16] The extra medium provided by the varnish held much darker blacks, but the artist lost the luxury of lifting or correcting marks placed on it. She also lost the luxury of time, as varnish dries in a matter of minutes.

By the end of 1919, O'Keeffe was evidently finished with this early phase of charcoal experimentation: a total of twenty-two charcoal drawings remain from 1915–1916; three from 1917, and only seven from 1918–1921.[17] When O'Keeffe returned to charcoal in 1926–1927, she again devised new ways of working to

1.

Georgia O'Keeffe,
A Street, 1926, oil on
canvas, Georgia
O'Keeffe Museum,
Santa Fe, Gift of The
Burnett Foundation

suit her new subjects. For example, in her 1926 study of skyscrapers *Untitled (New York)* (cat. 40), she worked the charcoal with a wet brush, drawing the particles down the sheet in thin washes. Apparently pleased with the effect, she re-created the transparent, particulate texture with oil paint in *A Street* (fig. 1). Her technique again changed during a 1934 visit to Bermuda, where she used charcoal in a simple, straightforward way that required control and skill. The charcoals from this time of exotic flora, for example, *Untitled (Banana Flower)* (cat. 44), are directly modeled. Drawn on a soft paper, ample pigment could be ground into the sheet to deliver deep rich black lines and shadows. But the soft sheets are not forgiving. Because they do not allow erasures or adjustments, the drawing had to be correct and sure from the start.

O'Keeffe kept all her charcoal materials together in a box that had contained typewriter paper (fig. 2). Scores of loose pieces of charcoal lay beside a small box containing natural charcoal sticks in three tones: #1, soft, gray; #2, semi-hard, dark gray; and #3, hard, black—all made by the French firm Bourgeois Ainé.[18] A number of the larger loose sticks were made by the American art supply house of Grumbacher, and a few sticks of compressed dark charcoal were manufactured by Koh-I-Noor of Czechoslovakia. Other paraphernalia include thick and thin stomps; sandpaper, for sharpening the charcoal; a soft cloth; many erasers; and a Rouget atomizer, a collapsible tube made by Winsor and Newton, London (for use with a fixative).

2.

Georgia O'Keeffe art materials, Georgia O'Keeffe Museum Research Center, Santa Fe, Gift of Anna Marie and Juan Hamilton

In 1916, O'Keeffe reintroduced color to her work. She remembered, "It was in the fall of 1915 that I decided not to use any color until I couldn't get along without it and I believe it was June before I needed blue."[19] For this, she chose Prussian blue apparently because it enabled her to replicate the tonal range she had found in charcoal.[20] Using thick and thin watercolor washes in abstract blue forms such as *Blue No. III* (cat. 8), she was able to add color to the curvilinear, shaded forms that she had created in charcoal the year before.

Watercolor is essentially different from charcoal. Charcoal had allowed O'Keeffe to erase and rework an image for days at a time, whereas watercolor, as she used it, was immediate. She could only manipulate a wash until it dried, and could not correct a design or remove any dry color from the paper she routinely used. O'Keeffe had used watercolor before: as a schoolgirl she had made landscape paintings using transparent watercolor, and in Chicago as a commercial illustrator she had used opaque watercolor, or gouache. But these had not prepared her adequately for her new work.

After about ten attempts'—I certainly have to laugh at myself—It's like feeling around in the dark—thought I knew what I was going to try to do but find I dont—guess I'll only find out by slaving away at it.[21]

Soon, she acquired some control in the medium. For the spectacular and relatively large watercolor painting *Nude Series XII* (cat. 16), she apparently prewet the sheet with clean water or a pale wash in the shape she wished to make. The water broke the surface tension on the sheet, and darker magenta watercolor could then flood the wet area without exceeding the boundaries. This very effective technique obviates the need for underdrawing and allows the color to appear pure, spare, and clean. The brilliant opaque yellow on the figure's back was introduced as the transparent pink was drying. The colors seem to move and merge in an organic way, creating a vibrant image.

O'Keeffe's watercolor nudes are reminiscent of those by Auguste Rodin, which she had seen at 291 in 1908[22] and in illustrations in *Camera Work* from 1911.[23] But O'Keeffe's *Nude Series XII* differs from *Figure Facing Forward* (fig. 3) by Auguste Rodin in an important way: her work shows no lines. In the O'Keeffe nude, only the drying line of the rich, abstract color defines the shape, while Rodin filled

a lively pencil drawing with a blush of naturalistic color. O'Keeffe's watercolor appears to be no more than a shadow; it is abstract, evocative, and emotional rather than descriptive or rational.

O'Keeffe's images made from concentrated abstract color break from earlier watercolors in technique as well as in treatment of subject matter. American painters such as Winslow Homer, John La Farge, and John Singer Sargent, who had earned substantial reputations as watercolorists by the end of the nineteenth century, used traditional British watercolor technique. Employing bright white paper to maximize the reflection of light through thin veils of color, they layered washes to build up designs over detailed pencil underdrawings. Their hard-sized paper permitted subtractive techniques, by which an already laid wash was reworked, reduced, or changed by rewetting and blotting, rubbing, scraping, or scratching. The rougher texture of their handmade sheets gave a dazzling, dappled quality to their color since tiny puddles dried slightly darker in the valleys than on the high points in the sheet.[24]

Although O'Keeffe had previously used both English watercolor paper and traditional painting techniques, in 1916 she chose a different paper that limited the range of watercolor techniques she could use. She selected a pale cream, fine-

textured paper, with a soft surface, that was sold as "drawing cartridge." Containing some esparto fiber, the paper has a slightly fuzzy, bulky feel, unlike traditional rag watercolor paper, which is hard-surfaced and dense.[25] Drawing cartridge paper was much less expensive than watercolor paper, and because it was made for students it was easily available to O'Keeffe. She remembered the paper as "regular school exercise paper."[26] Such disposable paper gave O'Keeffe the freedom to use and discard scores of sheets before obtaining an acceptable image. The drawback to this paper is that it does not allow subtractive techniques in watercolor. Therefore, O'Keeffe could not labor over effects as she had while working with charcoal. Instead, her nudes had to be made in one bold, all-or-nothing act, as the artist had only one chance to make it right.

O'Keeffe's virtuoso watercolor techniques and her consistent use of cartridge paper separate her watercolors from her contemporaries' work as well. Many modernists in Europe and almost all in the United States still used more or less complete pencil underdrawing on English handmade rag paper. They also employed the various subtractive techniques that had been used in the nineteenth century. These practitioners were able to change their imagery without necessarily amending their materials or techniques.

During 1916 and 1917, O'Keeffe occasionally used other papers for watercolors: these papers were apparently chosen either because of their size or because her regular "school exercise" paper was unsuited to the technique she wanted to use.[27] For example, she used a large sheet of traditional watercolor paper, probably handmade Whatman paper, for *Blue II* (cat. 6). In addition to its larger format, the surface of that paper is strong enough to withstand the broad wiping of color that creates the form in this work.

For the series that includes *Blue No. III*, she chose the beautiful glossy Japanese paper made from *gampi*.[28] *Gampi* paper is almost diaphanous—it is so thin and translucent. It also reacts characteristically to water, swelling considerably when wet. In this watercolor, the artist drew pale blues out of already laid darker blue strokes by applying clear water next to the drying, dark blue strokes. Responding to the water, the sheet cockled in a subtle, energetic pattern radiating from the image. On several occasions, she used a cream-colored traditional Japanese paper when she was exploring the effect of bleeding colors.[29] Although she did from time to time

use "found" sheets for her quick pencil sketches, she never used such sheets for her watercolors. During the critical years of her watercolor explorations, she consistently chose the most unobtrusive paper possible for her watercolors. The sheets she used are as neutral in color and texture as possible, given the demands of the medium. The paper is rendered inconsequential by these choices, and the applied color appears flat and hard-edged. Both qualities are important to her images, which seem to be composed of pure color floating in a neutral space. A paper of strong character would interfere with these ethereal images.

O'Keeffe also exercised control over her work in watercolor by deciding to use a consistent format. Most of her watercolors from the teens measure about 9 by 12 inches. Many are removed from a block of paper that size. However, when she used a single sheet of paper for watercolor, she often cut it to her standard size. O'Keeffe's particular habit was to fold a sheet in half, or in quarters, and then cut the sheets along the folds. In this way, she prepared a small stack of sheets that might vary in size by no more than an eighth of an inch. This habit probably started as a measure of economy while the artist was in school, or perhaps it was an exercise to replicate the discipline of Japanese woodblock print designers. In any case, her images in series are almost always on the same type of paper, and of a similar size. By adhering to a standard format, O'Keeffe was free to concentrate on the perfection of the design without the distraction of also determining size.

After moving to Texas in 1917, O'Keeffe began to paint the stark landscape with mixed results: "I've just come to the comforting conclusion that I'll have to paint acres and acres of watercolor landscapes before I will look for a passibly [sic] fair one," she confessed to Anita.[30] Despite her self-deprecating protestations, accomplished works such as *Evening Star No. V* (cat. 21) date from this time. In this watercolor, concentric rings of rich color fit together like pieces of a puzzle, pulsing from the bright glow of the star. The blocks of color could have been made by prewetting the intended shape with water before introducing the colored wash—the same technique O'Keeffe had used for the Nude series. But by 1917 O'Keeffe was fluent enough with watercolor to work more directly. It is more likely that each of the colors in the Evening Star series was applied in one sure stroke, with a sweep of a big sable watercolor brush. After one band of color had (almost) dried, the next could be applied, with little risk of marrying the colors. Intervals of blank

paper provide a hard edge to each band of color, which carefully avoided the edges of the sheet. The subtle darker lines of orange and red pigment radiating from the yellow star resulted when the watercolor washes settled in troughs created by the cockling of the unevenly wet sheet. Movement and variation are implied by the swirling of color at the center where the red and blue paints touch, and at the upper right where green paint was deliberately introduced into the wet blue field on a brush. The green appears to dispel the still wet blue, but is in turn covered by it. At the bottom center, a spot of blue paint was squeezed directly from the tube onto the wet surface. That "kiss of the tube" imparts both the deepest color and a glossy spot of excess medium. This work shows the particular beauty of watercolor: it appears to be a spontaneous expression in intense color.

In 1918, O'Keeffe painted a group of watercolors during a recuperative stay in San Antonio, Texas, that are more complicated in image, composition, and palette than were her previous works in the medium.[31] To accommodate these changes, she used a scant pencil drawing for many of the later works. *Woman with Blue Shawl* (cat. 26) was made in washes of brilliant blue and magenta, with vibrant orange accents. The rather limited palette in this work is barely noticeable since tones and mixtures of the colors are employed in rich variety. The blue shawl of the title turns the woman's form into an ambiguous shape, but the swing of the tassels and a line of merging neutral color at the hem of the skirt indicate the rhythmic sway of a woman's walk. The serrated, bleeding edges of the blue and the dappling of small white unpainted spots around the figure suggest bright, reflected light. The fluid dots of color that depict checks in the woman's apron are outlined by the visible pencil underdrawing that in other places is hidden by the dark washes. Such felicities of color and technique mark this group of watercolors.

Window — Red and Blue Sill (cat. 24), another work from this group, simultaneously shows all the techniques O'Keeffe could command in watercolor, and (from her point of view) the medium's particular limitations. Although in charcoal and in her first blue abstractions she seems to have explored a variety of ways to achieve subtle gradations in tone, in watercolor chromatic transitions are not easily rendered. The merging of color is additive, that is, a third, darker color is created by mixing two wet colors. In the blue to pink transition on the sill, or the blue to pale purple at the roof line, even in the pale blue highlighting of the reflection in the

window pane, the medium resisted the creation of tonal transitions that became an important part of O'Keeffe's aesthetic. Watercolor is simply not the proper tool for exploring the subtle shift of one color into another. For this she required the more opaque and controllable medium of oil or pastel. By June 1918, when O'Keeffe moved to New York to take up Stieglitz's offer of a free year to paint, she had apparently exhausted watercolor's appeal. From the momentous years 1916–1918, 114 watercolors remain. There are only 14 watercolors from 1919–1928.[32]

O'Keeffe returned to watercolor sporadically, but only a few sheets represent each of these episodes, and they show none of the spontaneous quality seen in the sheets from the teens. Twenty sheets, including a few small studies of flowers and of seaweed, and a handful of landscape studies, date from 1929–1936, and four landscape paintings date from a trip to Peru in 1956–1957. Finally, as her eyesight failed her, O'Keeffe recalled her abstract themes in watercolor one last time in 1976–1980. Although for these last works she used traditional watercolor papers that are whiter, heavier, and more textured than those she had used in the teens, none show the extreme texture available in such sheets.

Unfortunately, few watercolor paint materials connected to O'Keeffe survive, and these appear to date from 1953 through the mid-1970s.[33] She doubtless used tube colors throughout her career as a watercolorist, judging not only by the tubes remaining, but also by the evidence found in the watercolors from the teens. In a 1918 photograph made by Alfred Stieglitz, she works with semi-moist pan colors. *Georgia O'Keeffe: A Portrait—with Watercolor Box* (see page 56) shows the artist, delicately posed on the ground holding a big sable watercolor brush, using a bound block of watercolor paper; beside her a japanned black tin box holds full pans of colors.

Pastel afforded O'Keeffe a medium for her most unabashedly beautiful works of art. Exploiting pastel's broad range in hue and value, she was able to combine the graceful tonal imagery she had developed in charcoal with the intense abstract color she had explored in watercolor. Unexpectedly, she also found that pastel could project a captivating surface texture. In contrast to her brief campaigns of focused work in charcoal and watercolor, O'Keeffe, beginning in 1915, used pastel steadily throughout her career. She chose it as the focus of her first one-woman show at Edith Halpert's Downtown Gallery in 1952:

What would you [Halpert] think of a pastel show—It could cover all the years as it is something I have always returned to and could be very handsome—or even pretty—I do not mind the word as most artists do—I accept it as something pleasant that really adds to everyone's life unless their aesthetic ruts are too deep.[34]

Pastel sticks are manufactured by combining pigment and chalk white with a small amount of the gum tragacanth as a binder. The sticks are graduated in tone by varying the proportion of white so that each hue is represented in steps from the most intense to the palest value. Pastels are manufactured as soft, semi-soft, or hard, depending on the amount of gum in each. Soft pastels are quite velvety and can be layered over each other, although they tend to powder or shatter if the sticks are pressed vigorously into a paper support. Semi-soft and hard sticks are much more resistant to breaking and can be sharpened into a point for fine line drawing. All three types may be used in any particular work to create various effects.

Works in pastel are called pastel paintings probably because the technique has so much in common with oil painting. Colors can be blended directly on the surface of the painting, and very delicate transitions of color can be achieved. *Over Blue* (cat. 27), a stunning pastel from 1918, shows how well pastel fit O'Keeffe's needs. The gorgeous tonal shifts between colors—for example, from green to orange— were probably made by placing strokes of the different colors next to each other on the sheet. The artist could then blend them by lightly rubbing the color with her fingers. Blending a series of transitions could result in a sfumato effect, as it has in the deep blue field. If a hard edge between colors was wanted—as here, between the pink and blue—the artist laid one color slightly over the other, bearing down on the pastel stick. Harder pastel could be used to reinforce the outlines of color.

William Merritt Chase, O'Keeffe's painting instructor at the Art Students League, may have provided a model for her in pastel. A member of the Society of American Painters in Pastel, Chase used pastel as a studio tool to create easel pictures that are brilliant in both color and technique.[35] His *Back of a Nude* (fig. 4), for example, is a sheet completely covered by color. The strokes are softened and thoroughly blended in areas representing flesh or fabric. Because pastel sticks contain very little medium, the surface of a pastel is incredibly soft and delicate: it can actually be disrupted by the touch of a feather! Shock and vibration are often enough to dislodge pigment from a finished painting if it is not "fixed" by the

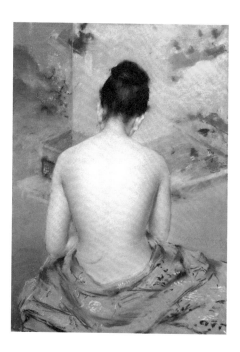

70

addition of a spray of varnish or of a medium to the pastel. Artists often resist the use of a fixative as it may slightly change both the color and the surface of a painting. Judging by *Back of a Nude*'s flat compacted surface, Chase may have squeezed this unfixed pastel in a press in order to increase the hold of the color to the paper support and make a somewhat more durable surface. O'Keeffe's habit of compressing her pastel strokes with her fingers achieves the same stability that Chase sought, but her pastels "remember" the process by which they were made: their sensuous surfaces still show the striated texture of the ridges in her fingerprint, or broader streaks deposited by the sticks of color. O'Keeffe apparently desired this slightly textured surface, for it became the norm in her work.

Whereas O'Keeffe's earlier pastels have an entirely smooth surface, her later works show a delicately modeled surface that echoes the forms of the subject. Compare, for example, highlights at the edges of colors in *Pond in the Woods* (cat. 36) from 1922 to the highlights on the edges of the petals in *Narcissa's Last Orchid* (cat. 50) from 1941. In 1922, O'Keeffe drew the white highlights on the apex of the ripple of water, but by 1941, the edge of the highlighted portion of the blossom is a subtle three-dimensional form. All the strokes and patterns of rubbing echo the natural form of the flower. At the edge of the form, the thickness of the pastel

powder was built up to form a ridge that both catches the light falling on the pastel and casts a slight shadow. The ridges of pigment at the edges of the shapes in O'Keeffe's pastels act as demarcations between the colored forms just as the blank white paper had set off forms in her watercolors. Sharp, clean edges are a delicate foil for the broad tonal transitions also seen in her work.

Throughout the 1920s, O'Keeffe's oil paintings increasingly came to look like her pastels. Of course, the oils, like the pastels, were blended, but more important, the palette became lighter and clearer in color, and the surface texture of the paintings diminished until it was as subtle and delicate as the surface of her pastels. Eventually, every brushstroke in her oil paintings reinforced the motion and volume in her forms.

O'Keeffe's technique of pastel painting created a surprisingly strong and stable pastel without the addition of a fixative.[36] The stability of her pastels is due to the compression of the pigment into the paper she chose as a support. At first she experimented with black photo album paper, but by 1918 she was using a gray or beige drawing paper mounted on cardboard. The paper had been flocked or else slightly abraded by the manufacturer to create a velvety surface that would hold the pastel. In some works on this support, threads of fiber from the paper can be seen embedded in the pastel. Although from a later period, *Untitled (Beauford Delaney)* (cat. 51) is on this type of sheet.[37] In 1926, she prepared and used a few cardboard supports with a white ground and gray priming layer, which were similar to supports she had prepared for oil paintings.[38] Also, in the 1920s she found a commercially prepared, beige paper that was encrusted with pumice or sand and mounted on a rigid cardboard. Its texture, which resembles a fine emery board, could secure a lot of pastel pigment on the surface. It was called *papier sans fix* in France and *snuffinpapier* in Germany; O'Keeffe probably purchased it as "pastel board" from an art supplier in New York.

O'Keeffe rarely allowed observers while she worked; we do, however, have a photograph of her workplace, Eliot Porter's *O'Keeffe Studio, Ghost Ranch, N.M., September 1945* (fig. 5), and a few unfinished areas in some of her works that allow insight into her pastel technique. In *Red Hills with the Pedernal* (fig. 6), the character of the support, a board covered with *papier sans fix*, can be seen in the unfinished area on the right edge of the pastel, slightly above the center. O'Keeffe

5.
Eliot Porter, *O'Keeffe
Studio, Ghost Ranch,
N.M., September 1945*,
1945, copy print
from black-and-white
negative, Amon
Carter Museum, Fort
Worth, P1990.68.381

apparently began by sketching the scene out in a preliminary drawing, which is just visible in the unfinished area near thick applications of pastel. This underdrawing is difficult to see because she used a cream-colored chalk that is very close to the color of the board itself. Elsewhere in the work, O'Keeffe smoothed the pastel into place with her finger or perhaps a small brush, completely covering the underdrawing with the opaque medium.

O'Keeffe's application of pastel could be vigorous. For instance, in the Porter photograph of O'Keeffe's studio, *Goat's Horns with Blue* (1945, private collection) is shown clamped on an easel surrounded by her pastel materials. The board is bowed, suggesting that it had to be tightly secured. O'Keeffe apparently applied the pastel in long sweeps, moving the stick back and forth across the sheet to fill in the large forms of the drawing. The underdrawing, again executed in a cream-colored pastel, is still visible in the Porter photograph at the edges of the large round goat's horn. Broad strips of color, each made by dragging a piece of pastel on its side, were carefully drawn just up to the underdrawing—on both sides of the lines—defining the form as both a positive and negative shape. O'Keeffe filled the abstracted horn with a midtone pastel that she layered with dark shadows and highlights. Her application of the lighter and darker colors varied: in some areas the color was pressed

6.

Georgia O'Keeffe,
*Red Hills with
the Pedernal*, 1936,
pastel on paper,
Brooklyn Museum
of Art, Bequest of
Georgia O'Keeffe

densely over the midtone, while in other areas it was drawn only lightly across the sheet. In the circles of sky visible through the curls of the horn, strokes in several tones create the same effect on a smaller scale. When the artist finally blended the colors, they merged into a broad field of slightly shaded color that gives the illusion of a three-dimensional form or a deep, receding space.

Pastel gave O'Keeffe time to experiment, a luxury she had exploited in her charcoal drawings in the teens. These works, unlike watercolors or even oils, could remain on her easel or in her studio for as long as it took the artist to consider the problems posed by the image. She could rework pastels by simply brushing pigment off the sheet and starting again. O'Keeffe often translated successful images into oil.

On the floor behind the easel in the Porter photograph rests an unfinished pastel, whose most interesting feature is the set of color notes at the top left corner of the board. Six tones are applied next to each other, with the board itself contributing a seventh color in the series. Arranged in order from dark to light, the colors look very much like a photographic gray scale, a tool that displays in mathematically graded steps the tones discernable in black-and-white photographic paper. O'Keeffe was apparently "setting her palette" for this work, organizing and

7.
Georgia O'Keeffe
art materials, Georgia
O'Keeffe Museum
Research Center,
Santa Fe, Gift of Anna
Marie and Juan
Hamilton

choosing colors in a tonal series. Her instructor at Columbia's Teachers College, Arthur Wesley Dow, suggested defining a five or seven step value scale, rendered in gray, as an exercise in his influential manual *Composition*. The student was encouraged to substitute colors in the scale, carefully keeping the value of the grays, as a means to develop "clarity of tone." [39] O'Keeffe employed a similar, but more highly organized system for choosing a tonal scale for her oil paintings. Perhaps as early as the 1930s, she painted out a number of graded tones in oil paint on pieces of canvas board, carefully recording the recipe for each color on the reverse. O'Keeffe kept the small colored squares together in her studio, taking them out to determine the color tone combinations desired in a painting. In 1996, a group of blue swatches was found held together with a rubber band; these apparently were the colors used in O'Keeffe's 1986 series of paintings commemorating a visit to the Washington monument with Juan Hamilton (see page 51, fig. 10).

O'Keeffe's concern with subtle tonal relationships, such as the range of gray tones displayed in *The Black Place III* (cat. 52), can be lost in the dazzling color of some of her work: for instance, her vibrant *Pond in the Woods*. However, even within the most brilliant composition she created a series of graduated tones. The balance of a neutral tone with its component colors can also be so subtle, so delicate that one must consciously look for it. For instance, in *Alligator Pear* (cat. 37), the initial impression that this is a work in black and white is dispelled as one studies the pastel. Slowly, one realizes that the avocado is brown; it rests on a neutral gray tabletop; and its "halo" is turquoise, which fades into a neutral gray space. The color balance O'Keeffe used reinforces the goal of her art: to invite a new look at what had first seemed to be familiar and simple.

O'Keeffe owned and used hundreds of pastel sticks made by numerous manufacturers (fig. 7). Some shallow wooden boxes that once held pastel sticks in organized ranks were found empty, or recycled among O'Keeffe's studio materials. Instead, scores of broken sticks and small pieces of pastels were grouped in boxes by color and a few were labeled pink, blue, and yellow in O'Keeffe's bold hand. These boxes were apparently opened as needed and spread out for use. In the Porter photograph of her studio, bits of pastel are spread out on a piece of brown paper. Each nugget was rubbed out to give an indication of its true color, as the sticks tend to become covered in a fine pastel dust in the box. The rubber gloves and the

crumpled paper towel on the table suggest that the artist, too, tended to become covered in fine pastel dust. The very large, rounded chunks of pastel seen in Porter's photograph are especially interesting. Unlike any known manufactured pastel, they are formed in the shape of a closed hand and impressed with the texture of canvas. Relatively coarsely made, with soft inclusions of dark pigment that was not completely mixed or small hard chunks of gum, they are of a quality that is not commercially viable. These were probably made by O'Keeffe. The recipe for pastels is quite simple, and the necessary ingredients were found among her studio materials: tragacanth and packets of powdered pigment (jars of it line the shelf behind her easel in the Porter photograph).

Georgia O'Keeffe was part of the first generation of American artists who could and did take all of their art training in the United States. Her training was traditional; it was also prolonged, as she took advantage of opportunities to study both how to make her own art and how to teach art in order to make a living. The crisis came for her as she tried to divorce herself from most of her training so that she could create something original. This training, however, was based on a complete respect for materials and, ultimately, it was her understanding of the tools of art that freed her to be original. In a relatively short time, she found new ways to use charcoal, watercolor, and pastel. She also found that she wanted to retain certain effects of each medium as she explored the next. All elements of her style were developed through a process of exploration and synthesis of media. Her tonal abstract images came from charcoal. Her clear brilliant color came from watercolor. These were fused, then refined, by the tonal and textural qualities she found in pastel. All was finally translated into oil, the medium by which she made her reputation and her fortune.

Surprisingly, the means and process by which she developed and realized her aesthetic were largely unknown. Because many key early works on paper were kept by the artist, they only became available after her death. Although O'Keeffe may have delayed a full understanding and appreciation of her work, she did ensure that all the pieces were kept together and that they were preserved in pristine condition. The physical condition of her works was one of her primary concerns: she believed the pristine look of her art was critical to its appreciation. She deliberately created a distinctive and delicate visual ideal that was precise and complete. Any changes to

the color or surface of her mature works are devastating. Her pictures, which must be viewed intimately, offer a startling incongruity: their pristine and subtle surface contrasts with the bold graphic design. The very act of looking at O'Keeffe's art can cause us to reconsider the exquisite beauty in the variations of color, tone, and texture found on the surface of a work, or in the objects and forms around us.[40]

1 From 1994–1999, I traveled with Barbara Buhler Lynes, author of *Georgia O'Keeffe: Catalogue Raisonné* (London and New Haven, 1999), in order to survey over one thousand works of art on paper by O'Keeffe. Dr. Lynes was completely generous with information and in discussing ideas. I would like to thank her for her help on this essay.

2 O'Keeffe's attention to the techniques of making art in order to create objects that were stable and long lasting deserves further study. She owned and annotated both editions (1934 and 1949) of Max Doerner's *The Materials of the Artist and Their Use in Painting with Notes on the Techniques of the Old Masters* and apparently made her own paints and pastels during the 1930s. From 1946 until her eyesight became too bad in the mid-1970s, she corresponded with Caroline K. Keck, a paintings conservator then in New York City whom O'Keeffe trusted with the treatment of her paintings. They corresponded about many issues, including painting structure and treatment. The Keck-O'Keeffe correspondence is housed at the Georgia O'Keeffe Foundation, Abiquiu, New Mexico. Sheldon Keck (Caroline's husband and colleague) told his students, including the author, that O'Keeffe would destroy any of her paintings that she believed had "failed" owing to a problem with art materials. She would also request that the Kecks perform prophylactic treatments on certain paintings to stave off the signs of aging.

3 Georgia O'Keeffe, *Some Memories of Drawings*, Introduction by Doris Bry (New York, 1974), unpaginated.

4 October 1915 letter, cited in Georgia O'Keeffe, *Lovingly Georgia: The Complete Correspondence of Georgia O'Keeffe and Anita Pollitzer*, Clive Giboire, ed. (New York, 1990), 46.

5 Thea Jirat-Wasiutynski, "Tonal Drawing and the Use of Charcoal in Nineteenth Century France," *Drawing* 11, no. 6 (March–April 1990), 121–124.

6 Harriet Stratis, "Beneath the Surface: Redon's Methods and Materials," in Douglas W. Drucik et al., *Odilon Redon: Prince of Dreams, 1840–1916* [exh. cat., The Art Institute of Chicago] (New York, 1994), 354–377, notes 427–431.

7 "Boston and the Barbizon," in Jean Gordon, *The Fine Arts in Boston, 1815 to 1879* (Ph.D. diss., University of Wisconsin, 1965), 223–283.

8 O'Keeffe's charcoal papers, all similar in type, were often identified by their manufacturers as "Ingres" paper (although the sheets are not the type used by that famous French draftsman). O'Keeffe used handmade sheets from French and Italian makers, including Arches, Michallet, and Fabriano. She also used Strathmore Charcoal, a high quality mould-made paper manufactured in the United States. All of these sheets are cream, medium weight, moderately textured, laid papers. They are hard-sized and specifically designed for charcoal or pencil drawing.

9 O'Keeffe 1990, 49 (October 1915 letter).

10 O'Keeffe 1990, 103 (December 1915 letter).

11 O'Keeffe 1990, 71 (October 1915 letter).

12 O'Keeffe 1990, 50 (October 1915 letter).

13 Jack Cowart and Juan Hamilton, *Georgia O'Keeffe, Art and Letters*, letters selected and annotated by Sarah Greenough [exh. cat., National Gallery of Art] (Washington, 1987), note on 147.

14 O'Keeffe 1990, 129 (4 February 1916 letter).

15 For a discussion of fixatives for charcoal drawings, see Karl Robert (Elizabeth Haven Appleton), *Le Fusain: Charcoal Drawing without a Master* (Cincinnati, 1880), 55–60.

16 Other charcoals from 1915–1916 by O'Keeffe, notably *Drawing XIII* and *Abstraction IX* (The Metropolitan Museum of Art, New York), show a brush application of varnish in areas of drawing.

17 Lynes 1999.

18 The Bourgeois Aîné art material house merged with LeFranc in 1965, creating the modern art materials manufacturer, LeFranc and Bourgeois.

19 O'Keeffe 1974.

20 Prussian blue has a very fine particle size and covers well. It has one of the longest tonal ranges of all pigments, from an almost black dark blue to the thinnest pale blue. For more information see Barbara Berrie, "Prussian Blue," in *The Pigment Handbook*, Elizabeth West Fitzhugh, ed., vol. 3 (Washington, 1997), 191–218.

21 O'Keeffe 1990, 145 (February 1916 letter).

22 Charles C. Eldredge, *Georgia O'Keeffe: American and Modern* [exh. cat., The Georgia O'Keeffe Foundation and InterCultura, Inc.] (Abiquiu, New Mexico, and Fort Worth, Texas, 1993), 19; see chronology.

23 *Camera Work* 34–35 (April–July 1911), illustrations on 24–25 and 36–43.

24 Judith Walsh, "Observations on the Watercolor Technique of Homer and Sargent," *American Traditions in Watercolor: The Worcester Art Museum Collection*, Susan E. Strickler, ed. (New York, 1987), 44–65.

25 The term "cartridge" originally described a paper that would burn without ash and could therefore be used to wrap powder for loading firearms. By the mid-nineteenth century, the term referred to a sheet of good, but not the best, quality. When O'Keeffe used it, the paper sold under the name "drawing cartridge," was machine-made, and contained some lesser fiber, in this case esparto, in addition to cotton or linen rag fiber.

26 "He [Stieglitz] had the idea that there must be a woman somewhere who could paint. When he saw my watercolors on regular school exercise paper, he thought I was that woman." Mary Lynn Kotz, "Georgia O'Keeffe at 90," *Art News* 76 (December 1977), 43, quoted in Lynes, *O'Keeffe, Stieglitz and the Critics, 1916–1929* (Ann Arbor, Mich., 1989), 320, note 13.

27 For example, O'Keeffe chose newsprint paper in order to achieve a desired effect in her 1917 watercolor series Light Coming on the Plains. See Judith Walsh, "The Paper Survey," in Lynes 1999, 25–26.

28 O'Keeffe may have obtained *gampi* paper from the Japan Paper Company, New York City. She requested its address from Anita Pollitzer; see O'Keeffe 1990, 97 (December 1915 letter). I am grateful to Anne Baldwin (Mellon Fellow, Brooklyn Museum of Art, paper conservation department), who kindly identified the fiber in *Blue No. III*.

29 She may have gotten the traditional Japanese paper from Stieglitz, who used it for his published photogravures. He had placed a huge order with a dealer in Germany in about 1897. Reams of this paper remain in labeled packets inside a solander box from 291 that is now in the possession of the Georgia O'Keeffe Museum Research Center. O'Keeffe used this type of paper for some of her nudes and for color studies in watercolor that have been related to the Light Coming on the Plains series.

30 O'Keeffe 1990, 145 (February 1916 letter).

31 Sharon R. Udall, *O'Keeffe and Texas* [exh. cat., Marion Koogler McNay Art Museum] (San Antonio, Tex., 1998), 108.

32 Lynes 1999.

33 Several tubes of watercolor paint made by Lucien Lefevre-Foinet, purchased in 1953, and some tubes of Winsor and Newton color from the 1970s remain in her leather painting kit now in the collection of the Georgia O'Keeffe Museum Research Center.

34 Washington 1987, 261 (10? September 1951, letter 109 to Edith Halpert).

35 See Marjorie Shelley, "American Pastels of the Late Nineteenth and Early Twentieth Centuries: Materials and Techniques," in Doreen Bolger et al., *American Pastels in the Metropolitan Museum of Art* [exh. cat., The Metropolitan Museum of Art] (New York, 1989), 33–46.

36 Stieglitz provided warnings about the fragility of the pictures on the reverse of some of the frames: one warning reads, "DO NOT JAR. This is an unfixed pastel. It could be fixed but fixing would somewhat alter the color." In spite of that, Doris Bry remembers O'Keeffe saying that the pastels were "stronger than you think" (private conversation with the author, 17 August 1999).

37 The reverse of this gray cardboard bears a brown paper label identifying it as having been sold from "S. Halpern Artist Materials, Picture Frames, and Photo Supplies, 506 Lexington Ave, N.Y., WIckersham 2-5494."

38 *Slightly Opened Clam Shell*, a pastel from 1926, is an example of a pastel on this type of support.

39 Arthur Wesley Dow, *Composition: A Series of Excercises in Art Structure for the Use of Students and Teachers* (Berkeley, Calif., 1997), 148–149, 167–168.

40 Georgia O'Keeffe 1974, quoted from the catalogue of her 1943 exhibition at An American Place.

Catalogue of
the Exhibition

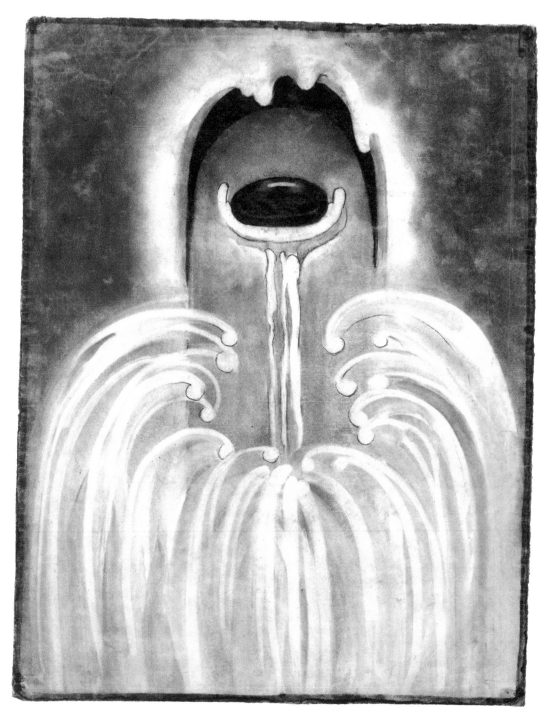

1. *No. 2 — Special*, 1915

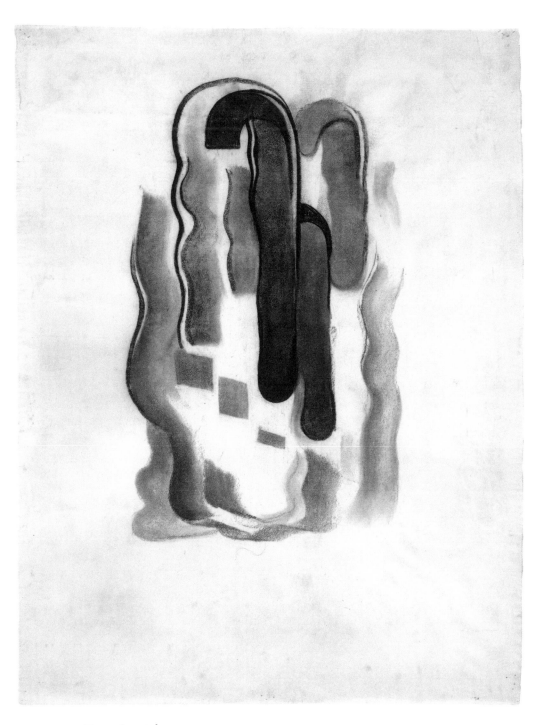

2. *No. 7 Special*, 1915

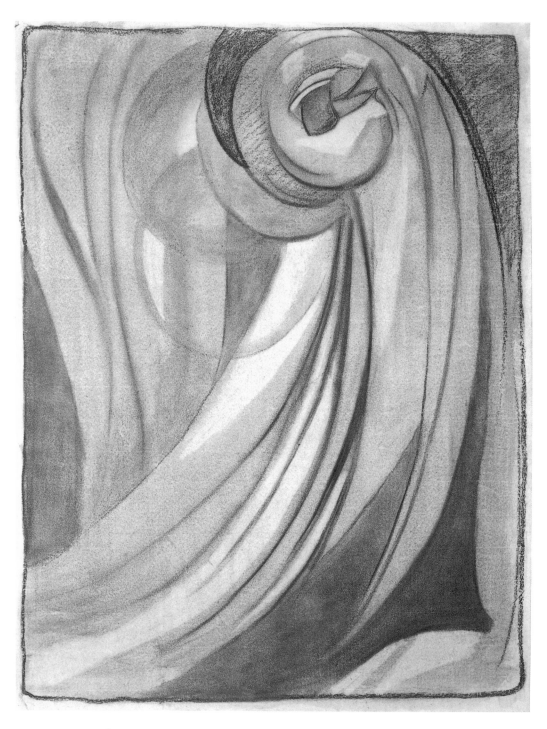

3. *Early No. 2*, 1915

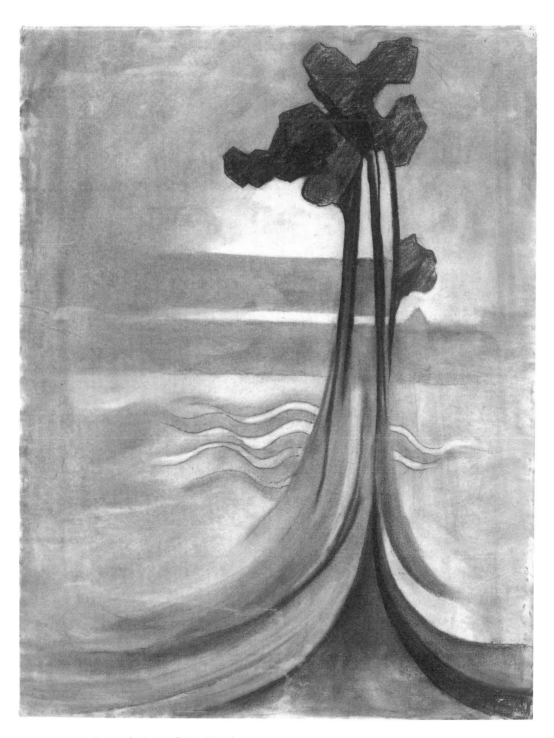

4. *Second, Out of My Head,* 1915

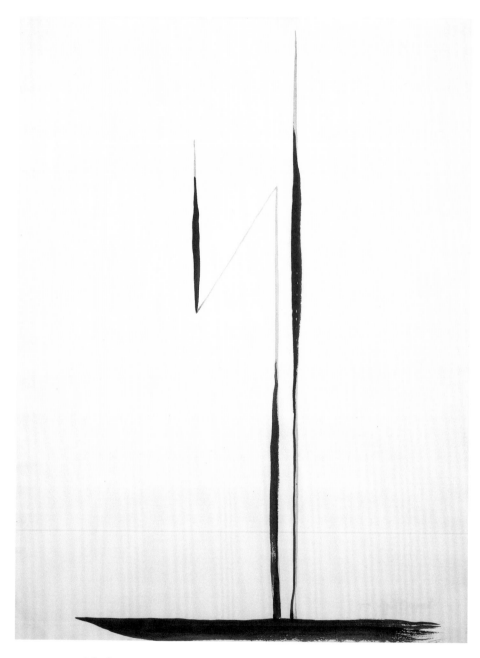

5. *Black Lines,* 1916

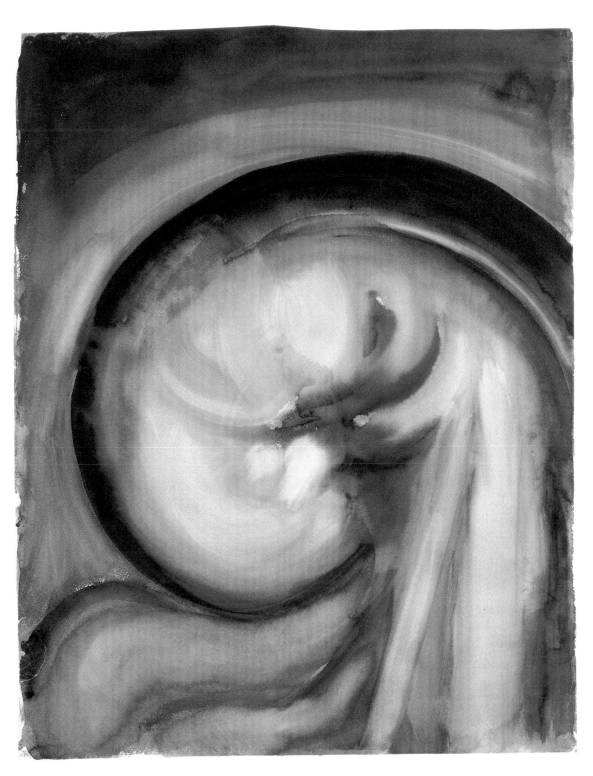

6. *Blue II*, 1916

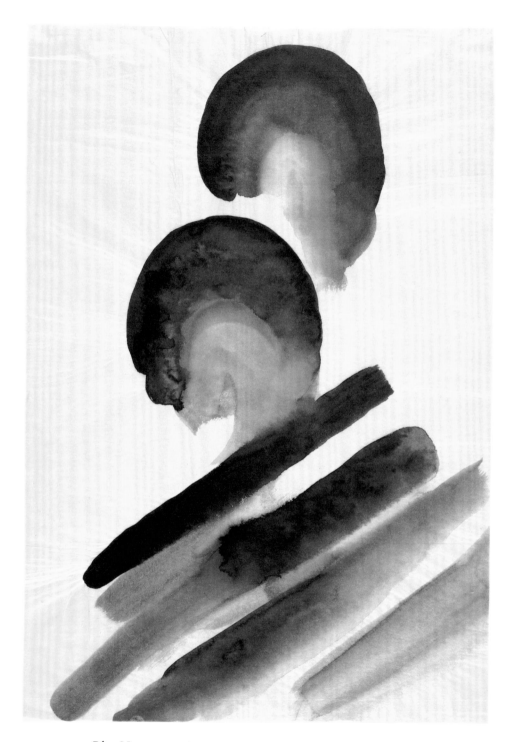

7. *Blue No. II*, 1916

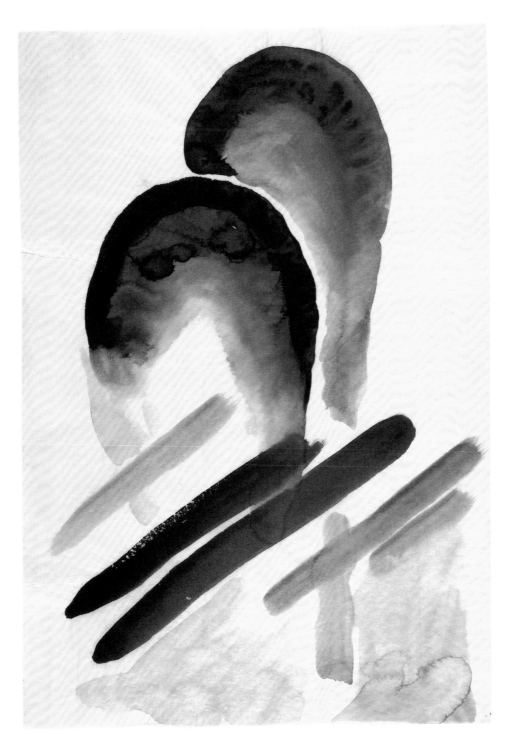

8. *Blue No. III*, 1916

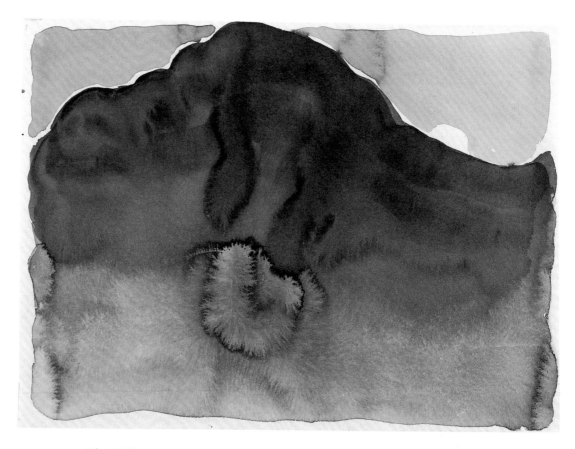

9. *Blue Hill No. 1*, 1916

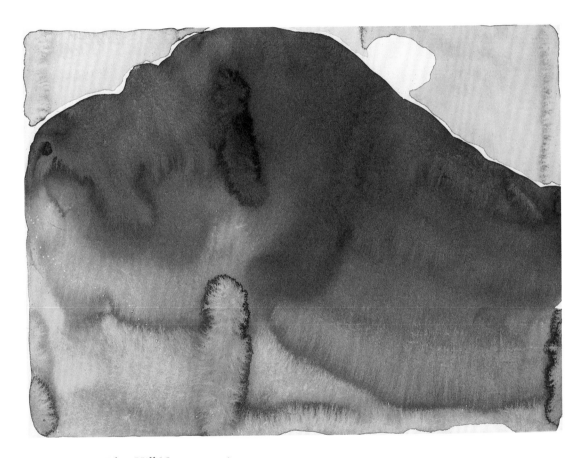

10. *Blue Hill No. II*, 1916

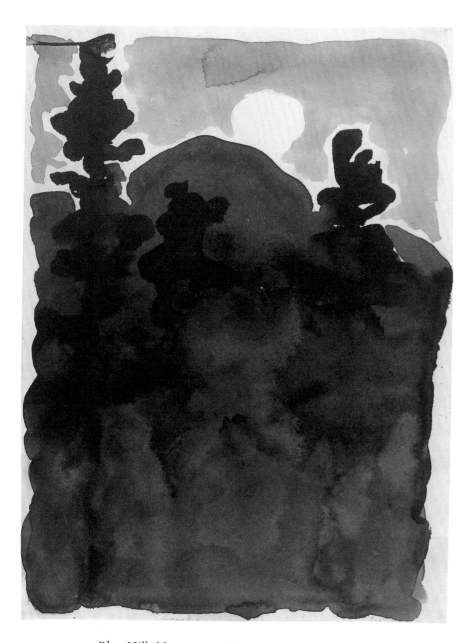

11. *Blue Hills No. III*, 1916

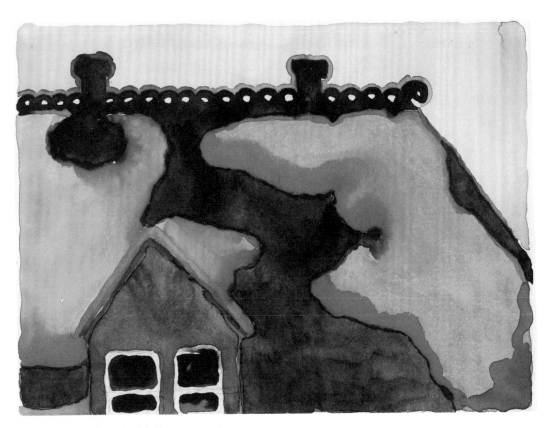

12. *Roof with Snow*, 1916

94

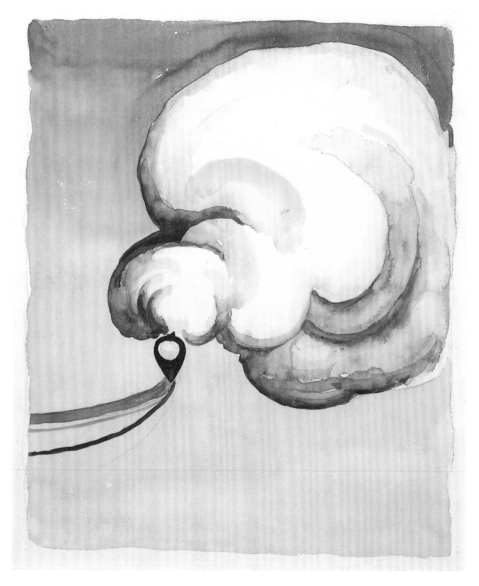

13. *Train at Night in the Desert*, 1916

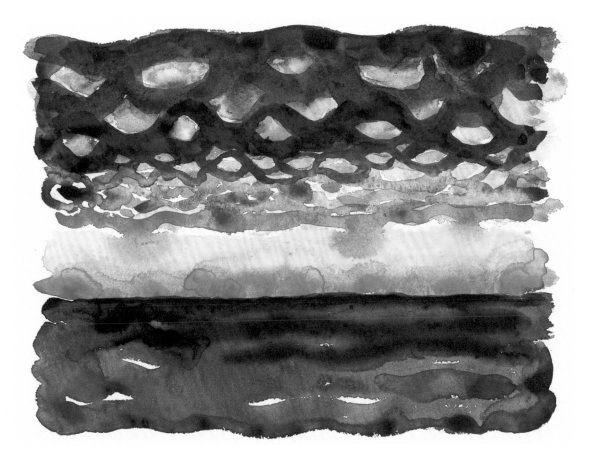

14. *Sunrise and Little Clouds No. II, 1916*

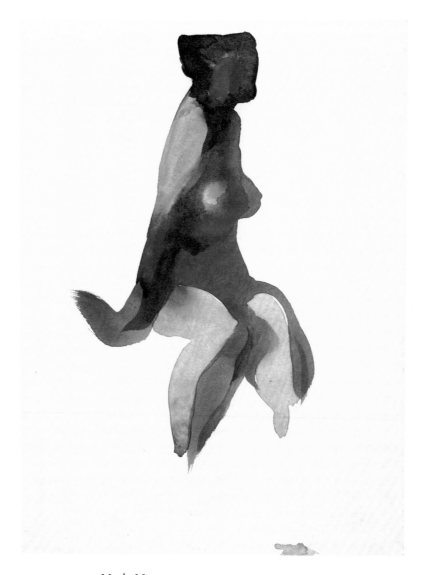

15. *Nude No. III,* 1917

16. *Nude Series* XII, 1917

98

17. *Untitled (Abstraction/Portrait of Paul Strand)*, 1917

18. *Untitled (Abstraction/Portrait of Paul Strand),* 1917

19. *Untitled (Abstraction/Portrait of Paul Strand)*, 1917

20. *Red Mesa,* 1917

21. *Evening Star No. v, 1917*

22. *Hill, Stream and Moon*, 1916/1917

23. *House with Tree—Green*, 1918

24. *Window—Red and Blue Sill,* 1918

25. *Three Women*, 1918

26. *Woman with Blue Shawl,* 1918

27. *Over Blue*, 1918

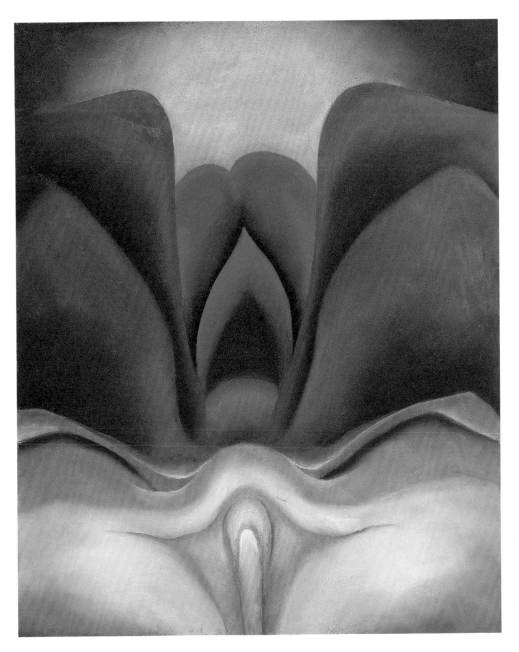

28. *Blue Flower*, 1918

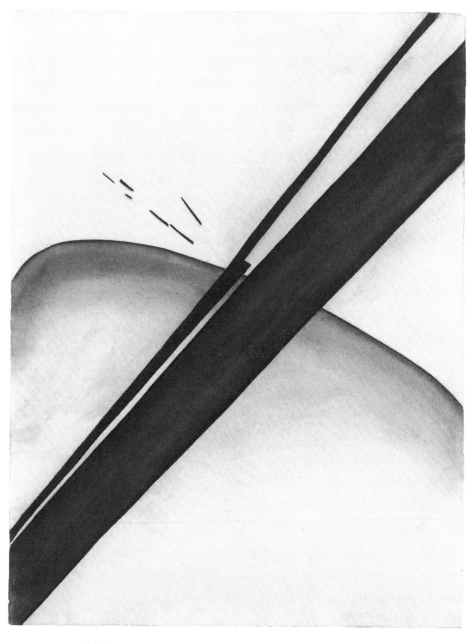

29. *Black Lines,* 1919

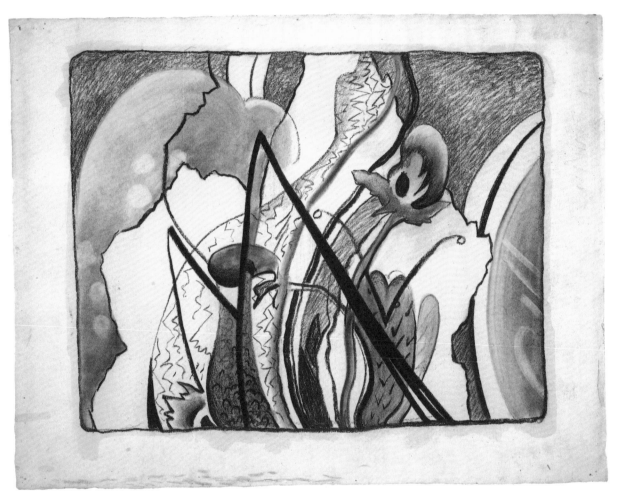

30. *Crazy Day*, 1919

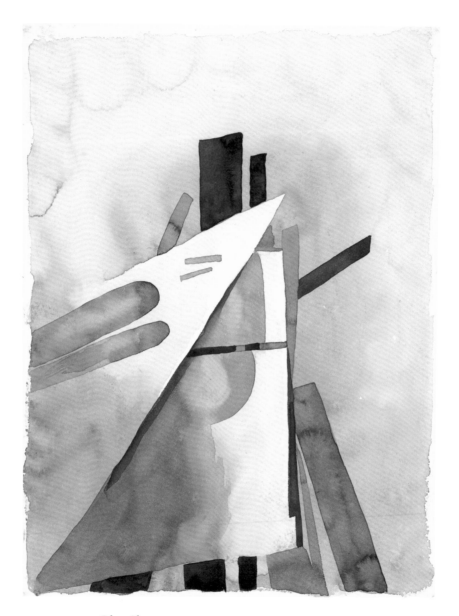

31. *Blue Shapes*, 1919

32. *Backyard at 65th Street*, 1920

114

33. *Abstraction of Stream*, 1921

34. *Lightning at Sea*, 1922

35. *Sun Water Maine*, 1922

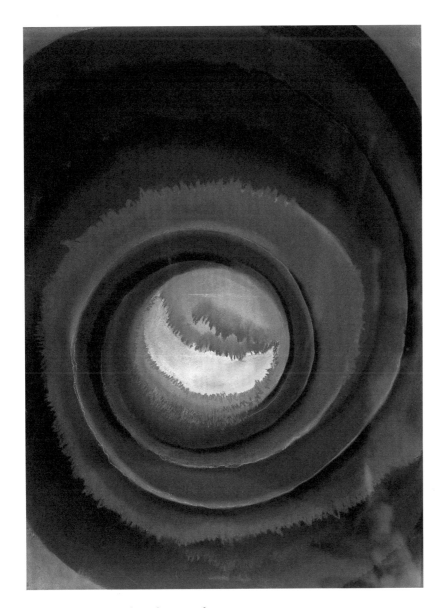

36. *Pond in the Woods, 1922*

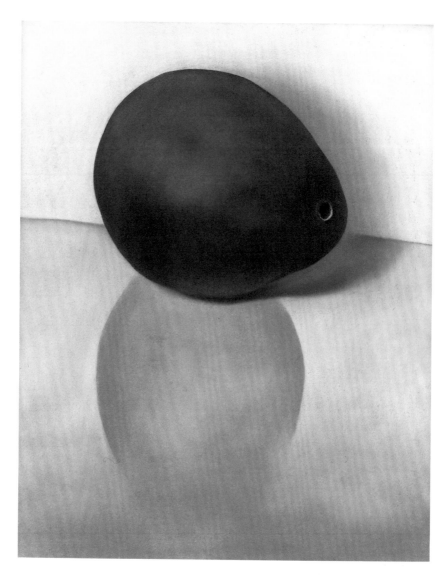

37. *Alligator Pear*, 1923

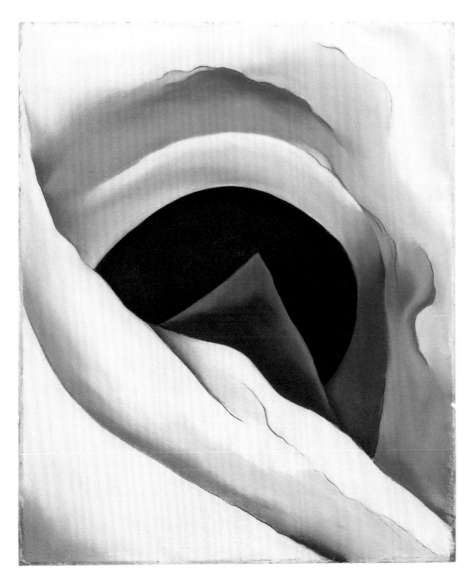

38. *Alligator Pears*, 1923

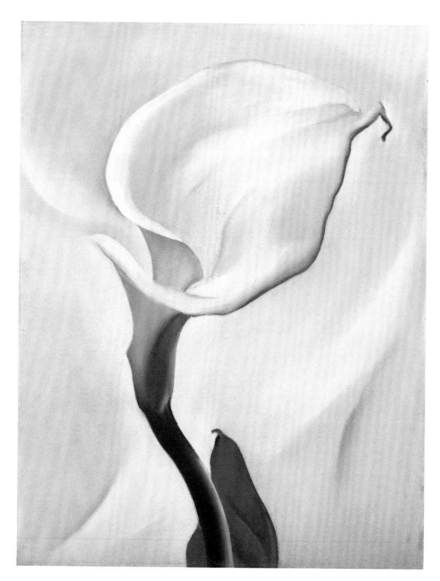

39. *Calla Lily Turned Away*, 1923

N

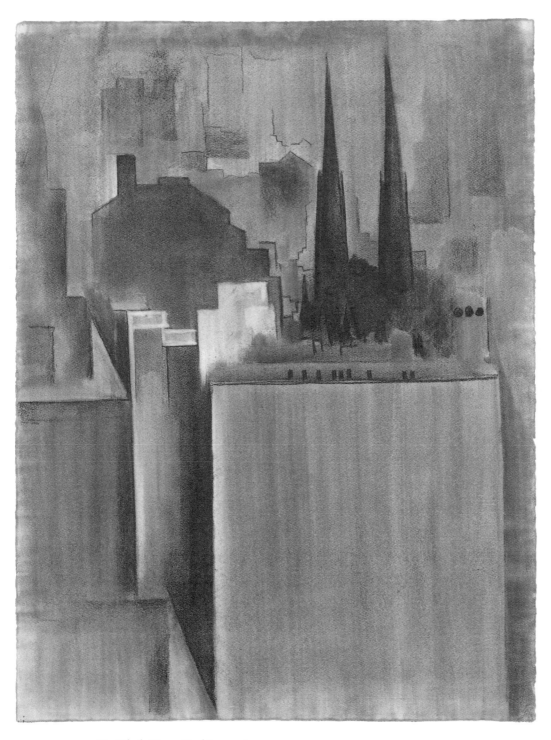

40. *Untitled (New York),* 1926

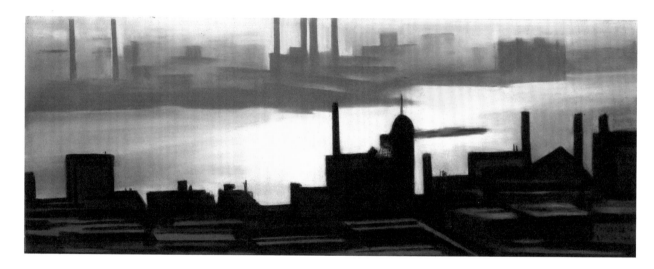

41. *East River*, 1927

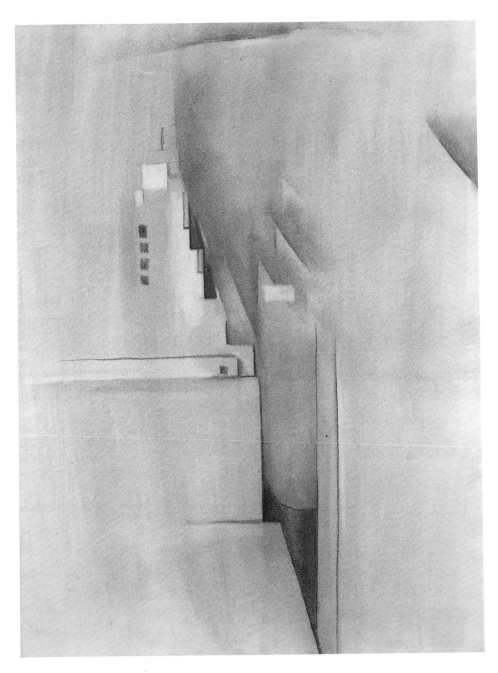

42. *Untitled (New York)*, 1932

43. *Kachina*, 1934

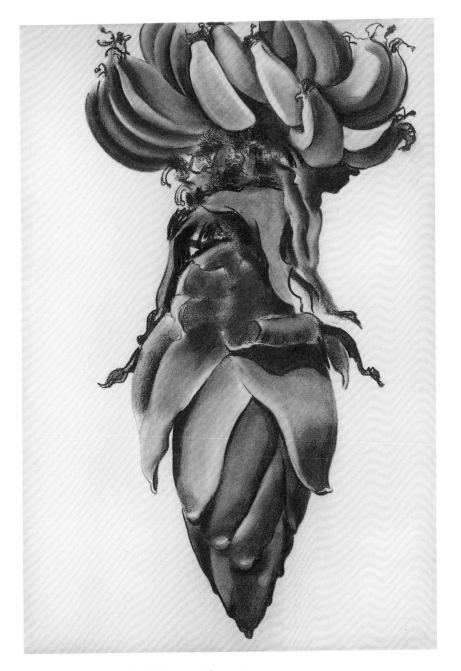

44. *Untitled (Banana Flower)*, 1934

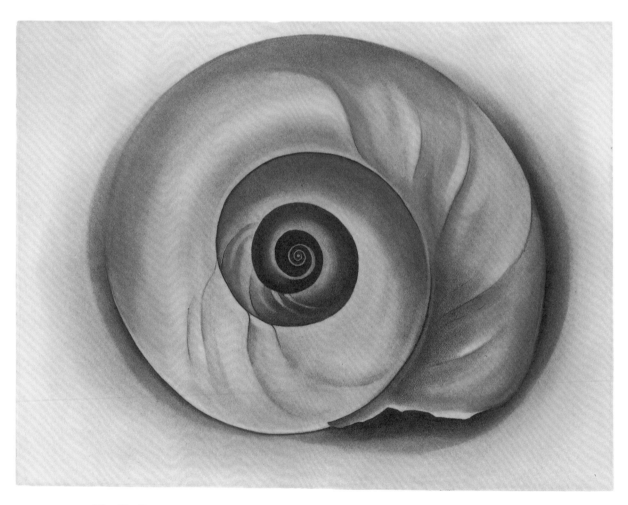

45. *The Shell*, 1934

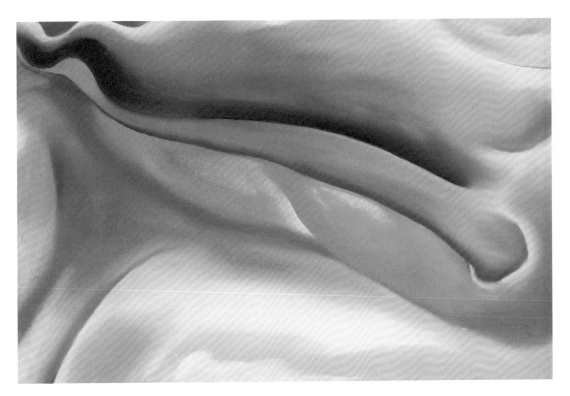

46. *Shell No. 1, 1931/1932*

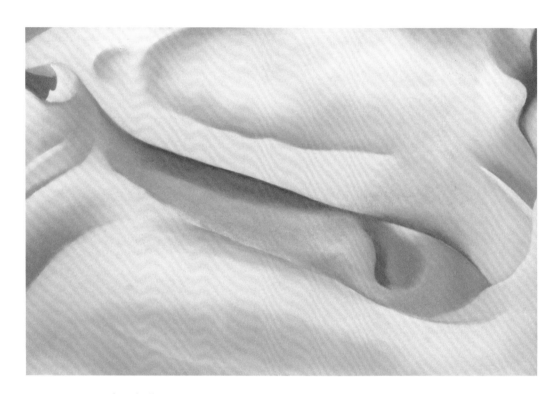

47. *The Shell,* c. 1934

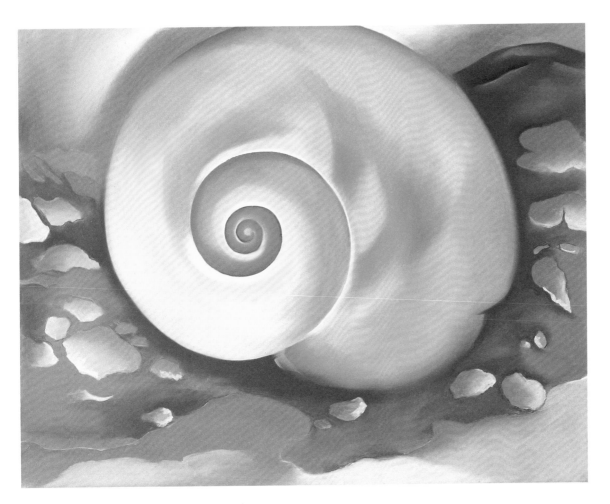

48. *Pink Shell with Seaweed*, c. 1938

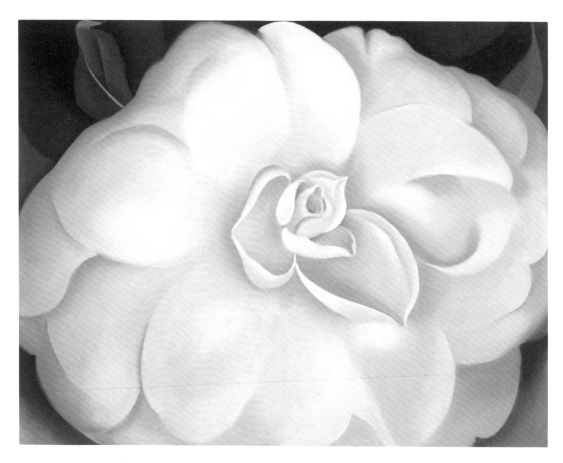

49. *A White Camellia*, 1938

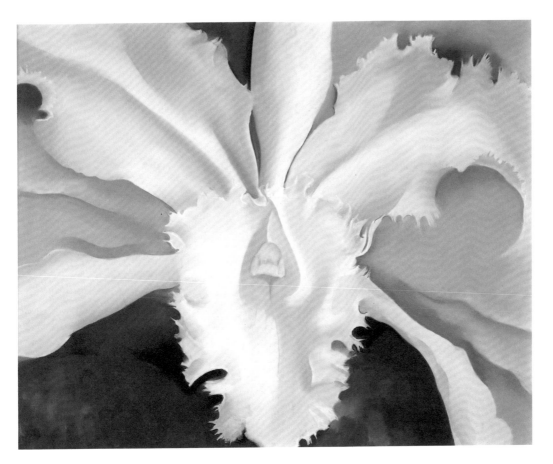

50. *Narcissa's Last Orchid,* 1941

51. *Untitled (Beauford Delaney)*, 1943

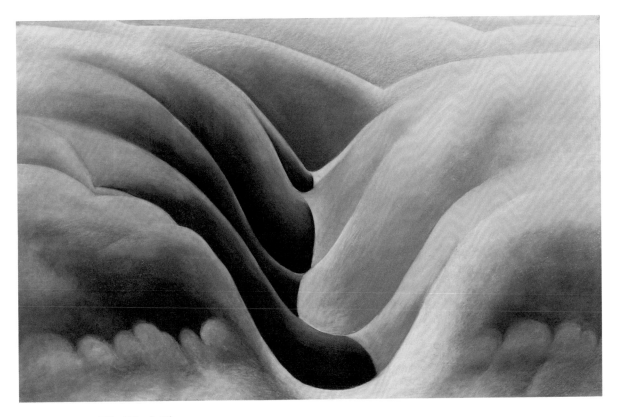

52. *The Black Place* III, 1945

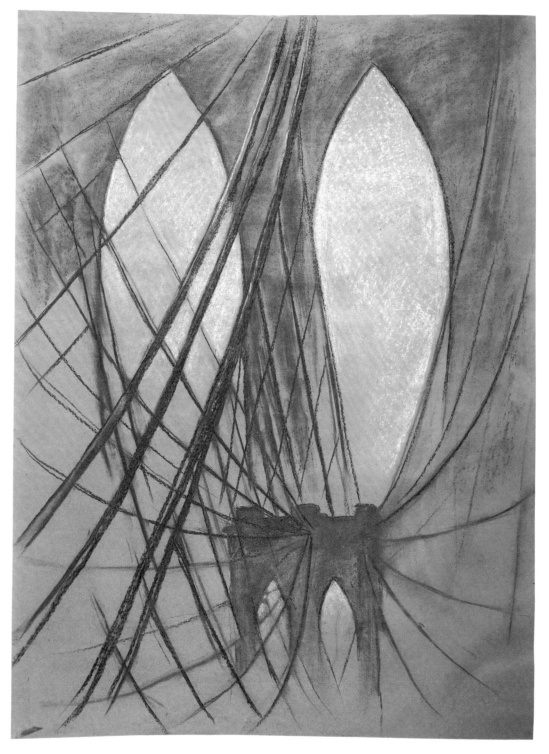

53. *Brooklyn Bridge*, 1949

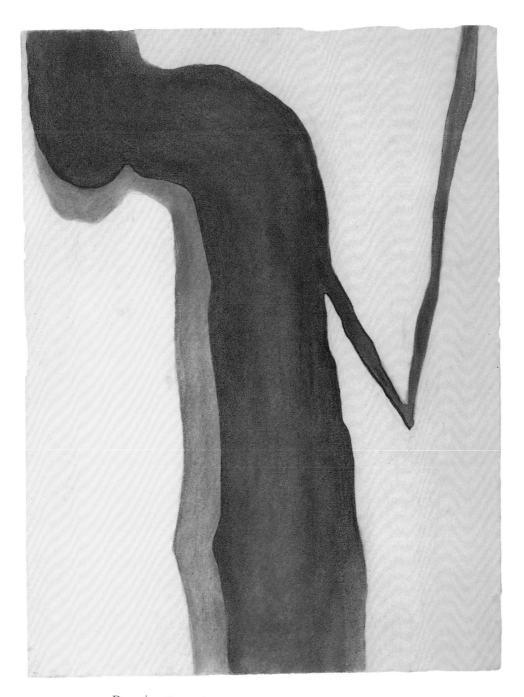

54. *Drawing V*, 1959

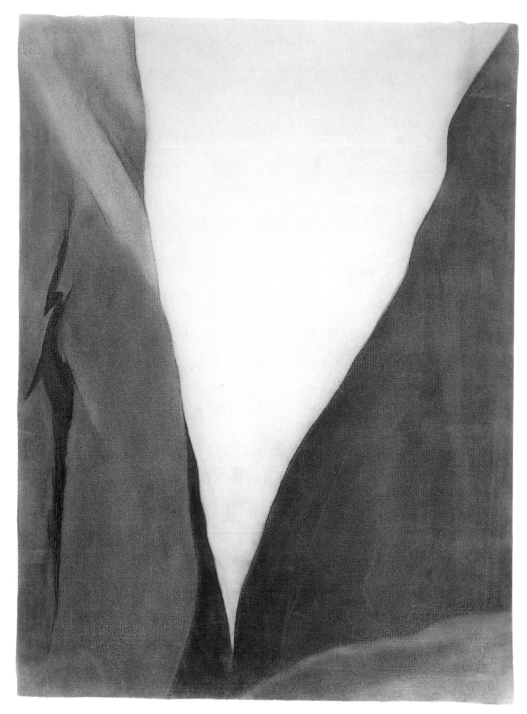

55. *From a River Trip*, 1965

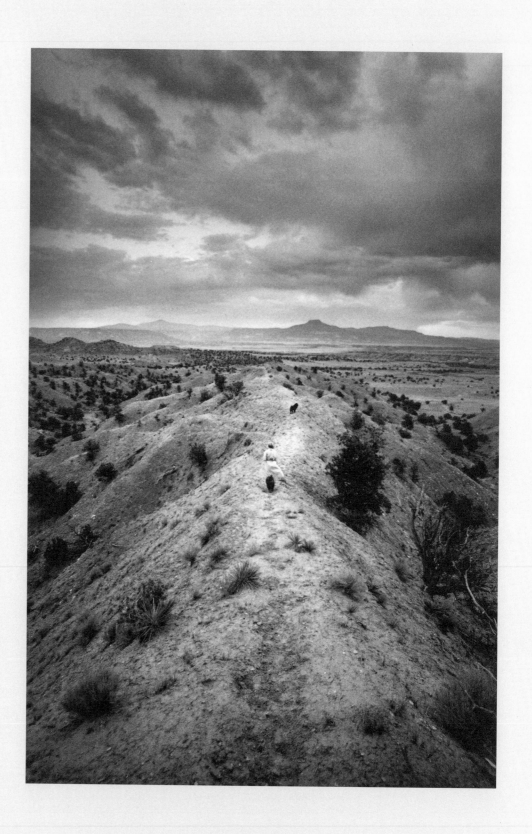

Checklist of the Exhibition

1. *No. 2—Special*
1915, charcoal
60 × 46.3 (23 ⁵/₈ × 18 ¹/₄)
National Gallery of Art, Washington,
Alfred Stieglitz Collection, Gift of
The Georgia O'Keeffe Foundation
(Washington only)

2. *No. 7 Special*
1915, charcoal
61 × 47 (24 × 18 ¹/₂)
National Gallery of Art, Washington,
Alfred Stieglitz Collection, Gift of
The Georgia O'Keeffe Foundation

3. *Early No. 2*
1915, charcoal
60.3 × 46.7 (23 ³/₄ × 18 ³/₈)
The Menil Collection, Houston, Gift
of The Georgia O'Keeffe Foundation
(Santa Fe only)

4. *Second, Out of My Head*
1915, charcoal
61 × 47 (24 × 18 ¹/₂)
National Gallery of Art, Washington,
Alfred Stieglitz Collection, Gift of
The Georgia O'Keeffe Foundation

5. *Black Lines*
1916, watercolor
62.2 × 47 (24 ¹/₂ × 18 ¹/₂)
Private Foundation, 1997, Extended
Loan, Georgia O'Keeffe Museum

6. *Blue II*
1916, watercolor
70.8 × 56.5 (27 ⁷/₈ × 22 ¹/₄)
Georgia O'Keeffe Museum, Santa Fe
Gift of The Burnett Foundation

7. *Blue No. II*
1916, watercolor
40.3 × 27.9 (15 ⁷/₈ × 11)
Brooklyn Museum of Art, Bequest
of Mary T. Cockcroft
(Washington only)

8. *Blue No. III*
1916, watercolor
40.3 × 27.9 (15 ⁷/₈ × 11)
Brooklyn Museum of Art,
Dick S. Ramsay Fund
(Santa Fe only)

9. *Blue Hill No. I*
1916, watercolor
22.9 × 30.5 (9 × 12)
The Georgia O'Keeffe Foundation,
Abiquiu

10. *Blue Hill No. II*
1916, watercolor
22.9 × 30.5 (9 × 12)
Dr. and Mrs. John B. Chewning

11. *Blue Hills No. III*
1916, watercolor
30.5 × 22.2 (12 × 8 ³/₄)
Private Collection

12. *Roof with Snow*
1916, watercolor
22.5 × 30.2 (8 ⁷/₈ × 11 ⁷/₈)
Amarillo Museum of Art Purchase

13. *Train at Night in the Desert*
1916, watercolor and graphite
30.2 × 22.5 (11 ⁷/₈ × 8 ⁷/₈)
Amarillo Museum of Art

14. *Sunrise and Little Clouds No. II*
1916, watercolor
22.5 × 30.5 (8 ⁷/₈ × 12)
Georgia O'Keeffe Museum, Santa Fe,
Gift of The Burnett Foundation

15. *Nude No. III*
1917, watercolor
30.5 × 22.5 (12 × 8 ⁷/₈)
National Gallery of Art, Washington,
Gift of Joan and Lucio Noto and
The Georgia O'Keeffe Foundation

16. *Nude Series XII*
1917, watercolor
30.5 × 45.4 (12 × 17 ⁷/₈)
Georgia O'Keeffe Museum, Santa Fe,
Gift of The Burnett Foundation
and The Georgia O'Keeffe Foundation

17. *Untitled (Abstraction/Portrait
of Paul Strand)*
1917, watercolor
30.5 × 22.5 (12 × 8 ⁷/₈)
Mr. and Mrs. Michael Scharf

18. *Untitled (Abstraction/Portrait of Paul Strand)*
1917, watercolor
30.5 × 22.5 (12 × 8⁷⁄₈)
Mr. and Mrs. Michael Scharf

19. *Untitled (Abstraction/Portrait of Paul Strand)*
1917, watercolor
30.5 × 22.5 (12 × 8⁷⁄₈)
Private Foundation, 1999, Extended Loan, Georgia O'Keeffe Museum

20. *Red Mesa*
1917, watercolor and graphite
22.2 × 30.5 (8³⁄₄ × 12)
Collection of Anna Marie and Juan Hamilton

21. *Evening Star No. V*
1917, watercolor
22.2 × 30.2 (8³⁄₄ × 11⁷⁄₈)
Marion Koogler McNay Art Museum, San Antonio, Bequest of Helen Miller Jones (Washington only)

22. *Hill, Stream and Moon*
1916/1917, watercolor
22.9 × 30.5 (9 × 12)
Ellen and Bill Taubman

23. *House with Tree—Green*
1918, watercolor and graphite
48.3 × 33.3 (19 × 13¹⁄₈)
The Georgia O'Keeffe Foundation, Abiquiu

24. *Window—Red and Blue Sill*
1918, watercolor
30.5 × 22.9 (12 × 9)
Georgia O'Keeffe Museum, Santa Fe, Gift of The Burnett Foundation

25. *Three Women*
1918, watercolor and graphite
22.5 × 15.2 (8⁷⁄₈ × 6)
Georgia O'Keeffe Museum, Santa Fe, Gift of Gerald and Kathleen Peters

26. *Woman with Blue Shawl*
1918, watercolor, graphite, and charcoal
22.5 × 15.2 (8⁷⁄₈ × 6)
Private Foundation, 1997, Extended Loan, Georgia O'Keeffe Museum

27. *Over Blue*
1918, pastel
69.8 × 54.6 (27¹⁄₂ × 21¹⁄₂)
Private Collection, Rochester

28. *Blue Flower*
1918, pastel
50.8 × 40.6 (20 × 16)
Collection of Anna Marie and Juan Hamilton

29. *Black Lines*
1919, charcoal
62.5 × 47.6 (24⁵⁄₈ × 18³⁄₄)
Addison Gallery of American Art, Phillips Academy, Andover

30. *Crazy Day*
1919, charcoal
47.6 × 62.2 (18³⁄₄ × 24¹⁄₂)
National Gallery of Art, Washington, Alfred Stieglitz Collection, Gift of The Georgia O'Keeffe Foundation

31. *Blue Shapes*
1919, watercolor
30.5 × 22.5 (12 × 8⁷⁄₈)
Collection of Anna Marie and Juan Hamilton

32. *Backyard at 65th Street*
1920, charcoal
63.5 × 47.7 (25 × 18³⁄₄)
Private Collection

33. *Abstraction of Stream*
1921, pastel
70.5 × 44.5 (27³⁄₄ × 17¹⁄₂)
Collection of Anna Marie and Juan Hamilton

34. *Lightning at Sea*
1922, pastel
48.3 × 64.1 (19 × 25¹⁄₄)
Museum of Fine Arts, Boston, Gift of the William H. Lane Foundation (Washington only)

35. *Sun Water Maine*
1922, pastel
52.1 × 67.9 (20¹⁄₂ × 26³⁄₄)
Anonymous

36. *Pond in the Woods*
1922, pastel
61 × 45.7 (24 × 18)
Private Collection

37. *Alligator Pear*
1923, pastel
30.5 × 25.4 (12 × 10)
Private Collection

38. *Alligator Pears*
1923, pastel
30.5 × 25.4 (12 × 10)
Collection of Marion Stroud Swingle

39. *Calla Lily Turned Away*
1923, pastel
35.6 × 27.6 (14 × 10⁷⁄₈)
Georgia O'Keeffe Museum, Santa Fe, Gift of The Burnett Foundation

40. *Untitled (New York)*
1926, charcoal
62.5 × 47.9 (24⁵⁄₈ × 18⁷⁄₈)
Fine Arts Museums of San Francisco, Achenbach Foundation for Graphic Arts, Gift of Charlotte S. Mack

41. *East River*
1927, pastel
28.6 × 72.4 (11¹⁄₄ × 28¹⁄₂)
Richard and Leah Waitzer

42. *Untitled (New York)*
1932, charcoal
62.2 × 47 (24¹⁄₂ × 18¹⁄₂)
Hirshhorn Museum and Sculpture Garden, Smithsonian Institution, Washington, Joseph H. Hirshhorn Bequest, 1981

43. *Kachina*

1934, charcoal

60 × 48.3 (23 5/8 × 19)

Georgia O'Keeffe Museum, Santa Fe,
Gift of The Georgia O'Keeffe
Foundation to honor the opening of
the Georgia O'Keeffe Museum

44. *Untitled (Banana Flower)*

1934, charcoal

54.6 × 36.5 (21 1/2 × 14 3/8)

The Hudson River Museum, Yonkers,
Bequest of Carl E. Hiller

45. *The Shell*

1934, charcoal

47.3 × 62.2 (18 5/8 × 24 1/2)

National Gallery of Art, Washington,
From the Collection of Dorothy
Braude Edinburg

46. *Shell No. 1*

1931/1932, pastel

24.8 × 37.5 (9 3/4 × 14 3/4)

Kirsten N. Bedford

47. *The Shell*

c. 1934, pastel

25.4 × 38.1 (10 × 15)

Mr. and Mrs. Leon E. Kachurin

48. *Pink Shell with Seaweed*

c. 1938, pastel

54.6 × 69.9 (21 5/8 × 27 1/2)

San Diego Museum of Art, Gift of
Mr. and Mrs. Norton S. Walbridge

49. *A White Camellia*

1938, pastel

54.6 × 69.8 (21 1/2 × 27 1/2)

Private Collection

50. *Narcissa's Last Orchid*

1941, pastel

55.2 × 69.9 (21 3/4 × 27 1/2)

The Art Museum, Princeton University,
Gift of David H. McAlpin, Princeton
Class of 1920 (Washington only)

51. *Untitled (Beauford Delaney)*

1943, pastel

48.9 × 32.4 (19 1/4 × 12 3/4)

The Georgia O'Keeffe Foundation,
Abiquiu

52. *The Black Place III*

1945, pastel

70.5 × 111.1 (27 3/4 × 43 3/4)

Private Collection

53. *Brooklyn Bridge*

1949, charcoal

101.3 × 74.9 (39 7/8 × 29 1/2)

Doris Bry

54. *Drawing V*

1959, charcoal

62.2 × 47.6 (24 1/2 × 18 3/4)

Georgia O'Keeffe Museum, Santa Fe,
Gift of The Burnett Foundation
and The Georgia O'Keeffe Foundation
(Santa Fe only)

55. *From a River Trip*

1965, charcoal

61 × 48.3 (24 × 19)

Private Collection, Washington
(Washington only)

A comprehensive bibliography for
Georgia O'Keeffe is included in Barbara
Buhler Lynes' *Georgia O'Keeffe: Cata-
logue Raisonné* (vol. 2), published in
1999 by Yale University Press, London
and New Haven, in association with the
National Gallery of Art, Washington,
and The Georgia O'Keeffe Foundation,
Abiquiu, New Mexico.

O'KEEFFE

*The Book Room: Georgia O'Keeffe's
Library in Abiquiu.* Essay by Ruth Fine.
Foreword by Elizabeth Glassman [exh.
cat., The Georgia O'Keeffe Foundation
at the Grolier Club] (New York, 1997).

Cowart, Jack, and Juan Hamilton.
Georgia O'Keeffe: Art and Letters.
Letters selected and annotated by Sarah
Greenough [exh. cat., National Gallery
of Art] (Washington, 1987).

Dijkstra, Bram. *Georgia O'Keeffe and
the Eros of Place.* Princeton, 1998.

Eldredge, Charles C. *Georgia O'Keeffe.*
New York, 1991.

Lisle, Laurie. *Portrait of an Artist:
A Biography of Georgia O'Keeffe.*
New York, 1980. Revised edition:
New York, 1987.

Lynes, Barbara Buhler. *O'Keeffe,
Stieglitz, and the Critics: 1916–1929.*
Ann Arbor, Mich., 1989. Reprint:
Chicago, 1991.

Messinger, Lisa. *Georgia O'Keeffe.*
New York, 1988.

O'Keeffe, Georgia. *Georgia O'Keeffe.*
New York, 1976.

O'Keeffe, Georgia. *Lovingly Georgia:
The Complete Correspondence of
Georgia O'Keeffe and Anita Pollitzer.*
Edited by Clive Giboire. New York,
1990.

Peters, Sarah Whitaker. *Becoming
O'Keeffe: The Early Years.* New York,
1991.

WORKS ON PAPER: O'KEEFFE

Georgia O'Keeffe: Drawings. Intro-
duction by Lloyd Goodrich. New York,
1968.

Georgia O'Keeffe: Works on Paper.
Essay by Barbara Haskell [exh. cat.,
Museum of Fine Arts, Museum
of New Mexico] (Santa Fe, 1985).

O'Keeffe, Georgia. *Some Memories
of Drawings.* Introduction by Doris
Bry. New York, 1974. Second edition:
Albuquerque, 1988.

WORKS ON PAPER: GENERAL REFERENCE

Bolger, Doreen, et al. *American Pastels
in the Metropolitan Museum of Art*
[exh. cat., The Metropolitan Museum
of Art] (New York, 1989).

Cohn, Marjorie B. *Wash and Gouache:
A Study of the Development of
the Materials of Watercolor* [exh. cat.,
Fogg Art Museum] (Cambridge,
Mass., 1977).

Elderfield, John. *The Modern Drawing:
One Hundred Works on Paper from
the Museum of Modern Art.* New York,
1983.

Finch, Christopher. *American Water-
colors.* New York, 1986.

Kushner, Marilyn. *The Modernist
Tradition in American Watercolors,
1911–1939* [exh. cat., Mary and
Leigh Block Gallery, Northwestern
University] (Chicago, 1991).

Rawson, Philip. *Drawing.* London,
1969.

Watrous, James. *The Craft of
Old-Master Drawings.* Madison,
Wisc., 1957.

Suggested
Reading